DIGITAL PHOTOGRAPHY
BEYOND THE CAMERA

IAN FARRELL

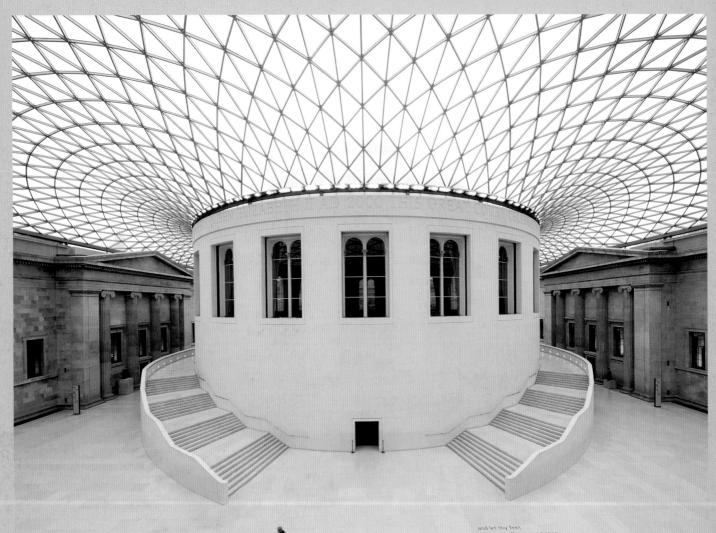

DIGITAL PHOTOGRAPHY
BEYOND THE CAMERA

Expert Photoshop and digital know-how for top-quality images and prints

IAN FARRELL

Ian Farrell
A DAVID & CHARLES BOOK
Copyright © David & Charles Limited 2007

David & Charles is an F+W Publications Inc. company
4700 East Galbraith Road
Cincinnati, OH 45236

First published in the UK in 2007
First US paperback edition 2007

Text and illustrations copyright
© Ian Farrell

A catalogue record for this book is available from the
British Library.

ISBN-13: 978-0-7153-2559-9 hardback
ISBN-10: 0-7153-2559-0
ISBN-13: 978-0-7153-2560-5 paperback
ISBN-10: 0-7153-2560-4

Printed in China by R R Donnelly
for David & Charles
Brunel House, Newton Abbot, Devon

Commissioning Editor: Neil Baber
Editor: Emily Pitcher
Project Editor: Nicola Hodgson
Art Editor: Marieclare Mayne
Production Controller: Beverley Richardson
Indexer: Lisa Footitt

Visit our website at www.davidandcharles.co.uk

David & Charles books are available from all
good bookshops; alternatively you can contact
our Orderline on 0870 9908222 or write to us at
FREEPOST EX2 110, D&C Direct, Newton Abbot,
TQ12 4ZZ (no stamp required UK only);
US customers call 800-289-0963 and
Canadian customers call 800-840-5220.

Contents

The introduction of digital cameras has revolutionized photography. In fact, apart from the development of light-sensitive materials into usable photographic film way back in the nineteenth century, I'm not sure that the practice has ever undergone such a radical transformation.

Things are moving quickly, too. Affordable consumer digital cameras have been available for less than ten years, yet in that time the quality and size of digital photographs has grown more than anyone would have thought possible. Things have become easier too, with the introduction of inexpensive, user-friendly software packages, which run on the most basic of computers and allow photographers to take control of how their pictures look after they have been conceived in camera. That is what this book is all about: taking control of photography beyond the camera.

Traditionally, photographers achieved this level of control by developing and printing their pictures in darkrooms, spending hours in the company of some fairly smelly chemicals in pursuit of the perfect picture. Many masters of photography claimed that this process was as much a part of picture-taking as going out with a camera in the first place. The legendary American landscape photographer Ansel Adams (1902–1984) was a great exemplar of this approach. His belief that photography does not stop in the camera was so strong that he developed a way of measuring the exposure with which to shoot a scene based on how he was going to print it – a technique known as the Zone System.

In the twenty-first century, digital photographers, whether they are beginners, enthusiasts or professionals, are obtaining this level of control too. Applications such as Adobe Photoshop give as much control of exposure, contrast and colour as the traditional darkroom ever did. In fact, they go much further, enabling precise, consistent manipulation of every factor in a picture. And because the result is reproducible at the click of a mouse, identical prints can be made with a desktop inkjet printer quickly and easily.

Hopefully, this book will get you thinking as Ansel Adams did. Before long, you too will be raising your camera to your eye and thinking about the treatment you are going to give a picture in your digital darkroom when you get home. Digital photography is a continuous learning process, and there is a lot to discover. But there are few things more rewarding than producing a print of a picture you have worked hard at, framing it, and hanging it on your wall.

Ian Farrell,
Cambridge

Getting started

Digital photography lets us experiment in a way we could never have done with film. After all, with a digital camera, it doesn't cost any more to shoot four or five frames of a scene, each from a different angle, than it does to shoot one. If you're not sure which of two compositions looks best, that's no problem – take both and decide later.

With this increase in picture-taking comes a problem, however: how do you keep track of all your images? You might have four different views of a landscape, together with the variations produced in Photoshop back at home, and further versions saved with different amounts of sharpening. Without a good filing system for your pictures, things can soon get out of hand.

Even basic steps, such as organizing the folders on your computer, can help in the quest to stay in control. There are also third-party applications available that let you sort images using a database; you can add keywords to the images so it's easy to find them later by performing a simple search (all pictures of your children taken at the seaside in the past six months, for example).

In this chapter, we will also look at how you can customize Photoshop – the application we will be using most of the time in this book – to help you improve your productivity. Photoshop is a huge application, and it is important to know how to make it look and work the way you want it to so you can use it effectively to edit your images.

We will also look at working with Raw files. This is an area of much confusion for many digital photographers, but if you have never tried shooting Raw, then you are missing out on the full potential that digital photography can offer. Working with Raw puts control and flexibility back where it belongs – with the photographer. It is also much easier than it looks.

Scanning is also worth a mention (as indeed it is later in the chapter), even in this age of cut-price digital compacts. Everybody has at least one image on film that they are proud of (some of us have thousands!), and transferring that image to your computer may mean you can improve it even further, as well as sharing it with your friends and backing it up so it's safe for future.

In this section we also investigate the concept of Digital Asset Management (DAM) – which is another way of saying 'keeping your pictures organized using a database'. Having a detailed and complex folder structure is one thing, but for the compulsives among us, a database that automatically catalogues images by data, subject matter, genre… in fact anything you can think of, is worth its weight in gold. With one of these beauties in your life, you will never lose a picture again.

Transferring files

The first step in taking your digital photography beyond the camera is to transfer your photographs from your camera's memory card and onto your computer. Here they can be enhanced, cropped, rotated and manipulated, before being printed, emailed and shown to the world on the web.

Transferring images is as easy as plugging your camera into your computer's USB port using the cable it came with. The memory card should appear as a disk like any other on your system, which you can browse and copy from. Some manufacturers supply software to do this for you, making things even easier. Transferring from your camera has a few disadvantages, however: first, the camera's battery must always be charged, and using it in disk mode drains whatever battery charge there is very quickly. Second, transferring files in this way is often very slow, as the type of USB connection employed in digital cameras is not always as fast as those in other devices. What's really needed is a card reader.

Above: Many card readers accept a variety of formats, which is useful if you own more than one digital camera.

Card readers

A card reader is usually one of the first accessories a digital photographer buys. This device can be left permanently attached to your computer, providing a slot into which you insert your memory card for fast and convenient transfer of image files onto your computer's hard disk.

Card readers come in different forms; which one you buy will largely be down to what type of memory card your camera takes, and what type of connection is available on your computer. If you shoot with more than one type of memory card/camera combination, then a multi-format card reader may be your best option. These units can commonly read up to twelve types of memory card, including CompactFlash, Secure Digital, Multimedia Memory Cards, Sony Memory Sticks and xD cards. They usually come with a USB connection; make sure the one you buy is of the USB 2.0 variety, as this offers transfer speeds several hundred times faster than the previous

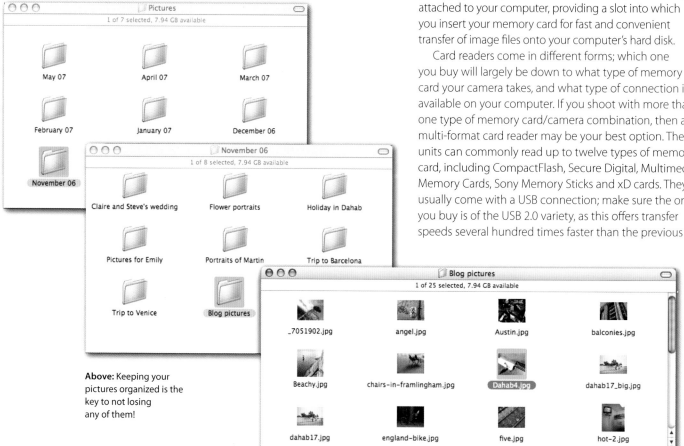

Above: Keeping your pictures organized is the key to not losing any of them!

incarnation of USB, called USB 1.1. Alternatively, you may want to try a FireWire card reader. In practice, FireWire connections are much faster when it comes to the sustained transfer of large quantities of data. They are more expensive, but they are worth the extra expense if your computer has a FireWire port and you shoot with large-capacity memory cards.

Organizing files on the hard disk

Once your image files are on your computer's hard disk, it is important to try to keep them organized. Digital photography means that we shoot many more pictures than before, and if you are not careful it won't be long before you can't find the image you want.

A simple and effective way of organizing your files is to split your My Pictures folder into directories according to date, then split each of these into subdirectories according to the subject of the shoot: 'Holidays in Egypt'; 'Lake District trip'; 'Claire and Steve's wedding', and so on. Using the Search command in Windows (or the Find facility in Mac OSX), you can search the entire parent folder for a subdirectory name, or go straight to it if you can remember the date the pictures were taken. Later in this chapter we will look at how to add descriptions and keywords to each image, and search through thousands of files for the one you want (see pages 26–27).

You could take this file organization one step further: why not have one set of folders for original files and a duplicate set containing copies of your images for editing? This would allow you to work on your pictures in image-editing software such as Photoshop with the reassurance that you could always revert to a copy of the original file should things go wrong.

PC or Mac?

The PC versus Mac debate has been raging longer than most normal people can remember. In fact, both Windows and OSX (the Apple Macintosh operating system) can do a great job for the majority of digital photographers, and the decision about which platform is right for you is down to personal preference. At first glance, Apple Macs seem more expensive than PCs, and if you are comparing them to the bargain-basement Windows machines that are available then this is probably true. However, once you factor in the added extras that Macs often have (such as separate graphics cards, FireWire connectivity and Bluetooth), there is actually very little difference.

Some photographers prefer the extra flexibility of the PC, which has more software available for it, whereas other users like the space-saving design of Macs and the (arguably) more productive operating system. Apple probably has a better system of colour management than

Windows, but unless you are planning to be an advanced Photoshop user, this may not matter to you.

Apple machines have recently been revamped so that they all now run with the same Intel chips as PCs. This has made them much faster than before, and also means that with a little effort you can get them to run Windows as well as the Mac OSX operating system. If you are having trouble choosing which system to opt for, this might just prove to

be the deciding factor. Ultimately, the decision of which platform to go for is down to you and your preferences. The compatibility problems of the past are long since gone, and Mac and PC users can share pictures between their systems with no problems. Just remember that neither system will make you a better photographer!

PCs and Macs are both capable of helping you create excellent digital photographs; your choice of which to use will largely be dictated by personal preference.

Backing up

Making back-ups is an essential part of digital photography. It is not really a case of 'if you have a disk failure…' as much as 'when you have a disk failure…' A wise man once said that hard disks have only two states of being: crashed, and about to crash.

Let's suppose you adopt the duplicate file structure system discussed on pages 10–11, with separate directory structures for original and edited files. It makes sense to back these up separately, either on an optical disk, such as a CD or DVD, or on a separate external hard disk. Each of these options has its advantages and disadvantages. The good points are that CDs and DVDs are cheap, and the amount of

storage they provide is limited only by the number of disks you have. DVD-burning drives are commonplace now, but if your computer doesn't have one built in, separate external drives that connect via USB 2.0 or FireWire are available quite cheaply. The downside is that optical disks can take some time to write to, and their read speeds are nowhere near as fast as a conventional hard disk. Furthermore, to archive 250 gigabytes (GB) of data you would need more than 50 disks, which would make restoring lost files very time-consuming. Therefore, it is best to use an external hard disk for an archive that is accessed regularly.

External hard disks use the same storage media as the internal hard disk in your computer, except they are housed in a separate casing that connects via USB or FireWire to your PC or Mac. They are typically very fast

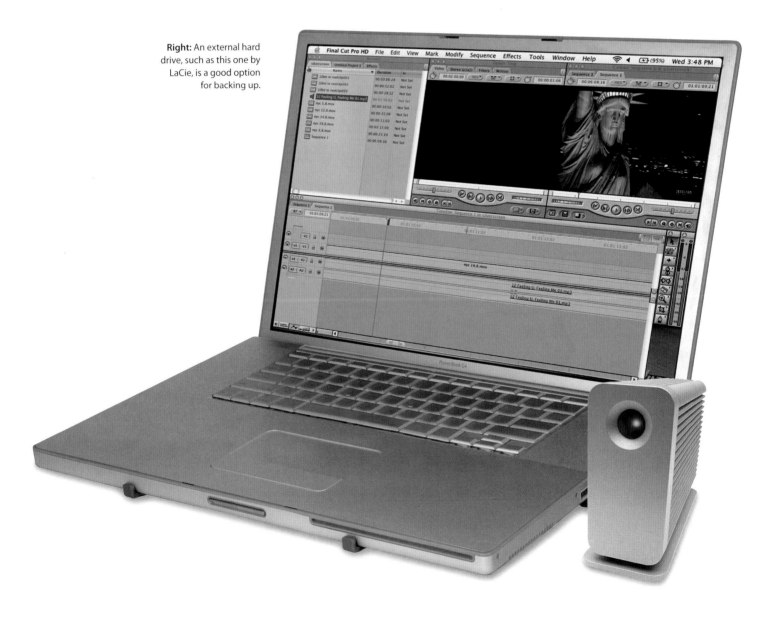

Right: An external hard drive, such as this one by LaCie, is a good option for backing up.

and offer large capacities, currently peaking at about one terabyte (1TB). They are less robust than optical disks, so be careful how you treat them.

Making a back-up copy of your files can be as simple as dragging and dropping your files manually to their new destination. However, this can be a chore, and chores quickly develop into reasons to procrastinate, which can result in data loss. Another way of getting the job done is to opt for some dedicated back-up software. This compares the working disk with the back-up disk and copies only those files that have changed, thereby shortening the process considerably. Back-up applications can also schedule the process and carry it out automatically, meaning that the job can be done regularly and at a time when you are not using your computer – every Tuesday at midnight, for example.

However you make your back-up, it is good practice to keep the disk containing it off-site, perhaps in a friend's house, or at your workplace. After all, if the worst happens and fire or theft means you lose your back-up as well as everything else, there's not much point in making one.

Backing up online

A third method of backing up is to find an online option. There are pros and cons to this approach, so although it may not suit everyone, it is worth considering. There are a number of Internet companies that will make space on their servers available to you and your precious image files. Tap 'online back-up' into a search engine and you will find a good number.

Above: Externals disks that are fast and offer large capacities are now good value for money.

Below: Back-up software, such as SilverKeeper by LaCie, can automate the back-up process, making the task less tedious.

The main advantage with these services is that your data is much more secure than if you back it up at home. Professional back-up companies will store your information across a number of computers (called mirror sites), which are often in completely different towns, just in case the worst happens at their end too.

The main downside of an online back-up strategy is the cost involved. Most companies charge per gigabyte of storage required, so if you are backing up high-resolution Raw files, the cost can soon mount up. The expense may be worth it, but bear in mind that you could easily spend in a year the equivalent price of two external drives. When it comes to confidence in your back-up solution, you get what you pay for.

Another potential disadvantage to this method is that transferring files to an online provider is much slower than making a back-up locally. Whereas a FireWire connection allows data transfer at up to 400 megabits (Mbits) per second, even broadband Internet connections reach only approximately 4–6 Mbits per second.

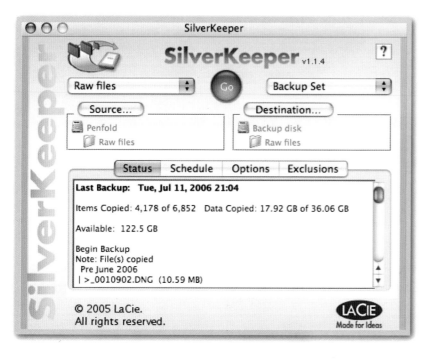

SilverKeeper

SilverKeeper v1.1.4

Raw files · Go · Backup Set

Source... · Destination...

Penfold · Backup disk
Raw files · Raw files

Status · Schedule · Options · Exclusions

Last Backup: Tue, Jul 11, 2006 21:04

Items Copied: 4,178 of 6,852 Data Copied: 17.92 GB of 36.06 GB

Available: 122.5 GB

Begin Backup
Note: File(s) copied
 Pre June 2006
| >_0010902.DNG (10.59 MB)

LaCie
Made for Ideas

Working with Photoshop

The application used more than any other in this book is Adobe Photoshop. This program has been around since 1990 and has become the de facto industry standard for editing images – not just among the graphics professionals, at whom it was originally targeted, but with home photographers too. In the late 1990s, Adobe released Photoshop Elements, a version of the application targeted more towards the home user, with a price tag to match. You will find that many of the tips and tutorials described in the pages to come also work in Photoshop Elements, although a few require the latest version of the full program (Photoshop CS2) to function correctly.

Customizing screen layout

Photoshop is a massive program, and over the years, as more and more features have been added, it has become somewhat unwieldy. Anything you can do to make the application more friendly to use is very welcome, and at the top of the list is customizing the screen layout.

Version 1 of Photoshop had just two palettes; version 9 (CS2) has dozens. Thankfully, however, it is possible to move these around to make them easier to work with, docking them to the sides of the screen or hiding them when they are not in use. Photoshop's palettes are organized in groups to reduce screen clutter. By default, the Navigator, Info and Histogram palettes are grouped together, for instance. But what happens if this doesn't suit the way you are working? No problem: simply pick up the palette and move it by dragging its tab. You can move it into another group, or simply drag it into free space to create a new group.

There are several areas of Photoshop's user interface that can be customized in this way. These include

Above: Adding a keyboard shortcut for a 90-degree rotation (see opposite page).

Right: Moving palettes between groups to organize your screen layout is simple: just drag them around by their tabs.

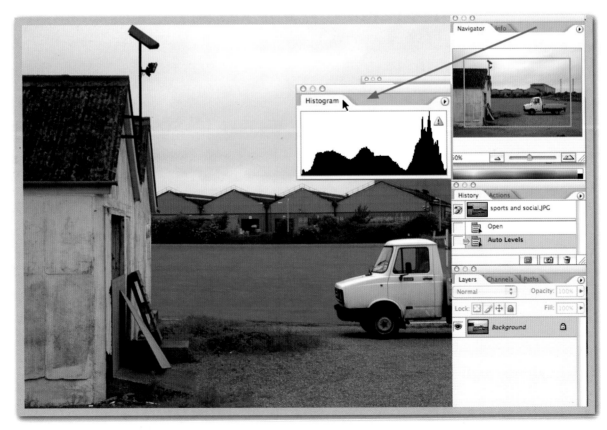

keyboard shortcuts. All the well-known ones are already set: Ctrl+A for Select All and Ctrl+H to Hide or Show Guide are just two of the hundreds available. You can also create your own shortcuts. For example, it is a mystery why Adobe don't include a shortcut for rotating images by 90 degrees, but you can add one yourself by following these steps:

01 Select Edit > Keyboard Shortcuts to bring up the Keyboard Shortcuts dialog box. Find the command to be assigned a shortcut and click it once to make it active. In this case, 'Rotate Canvas 90° CW' is listed under the Transform section of the Edit category, mirroring its placement in the menu hierarchy.

02 Click Rotate Canvas 90° CW and hit the keystroke you want to use as a command – in this case, Shift+Option+R. If you choose a keystroke that is already in use, Photoshop will tell you and remove it from the command to which it is currently assigned. When you are done, click OK then Accept.

Below: Adobe Photoshop is the most widely used image-editing application, popular among both digital professionals and amateur enthusiasts.

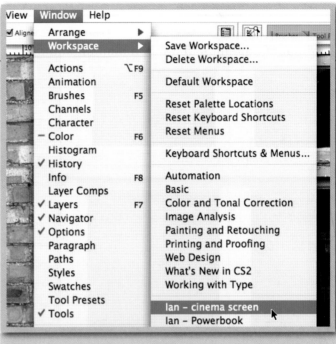

Set Photoshop to remember your palette locations so you can reset them quickly.

Tool Presets is a useful feature for recalling groups of settings.

Remembering palette positions

An intense session of Photoshop can leave your screen looking a bit of a mess, so it is a good idea to memorize the positions of your palettes after you have spent valuable time configuring your ideal working space. When you are happy with things as they are, select Windows > Workspace > Save Workspace. Enter a name and click OK. You will see this name at the bottom of the Windows > Workspace menu now; select it any time you wish to go back to this configuration.

Also useful is Photoshop's Tool Presets feature, especially if the same task is performed often. The Tool Preset is shown by default near the top left corner of the screen and includes some preset values to get you started. The idea is that if, for example, you regularly crop to a certain size, you can save those settings as a preset so you don't have to keep remembering them and entering them by hand.

Calibrating the screen

Both Windows and Mac OSX include utilities to calibrate your screen. Using them means that you will be looking at an industry-standard shade of white, and a correct contrast and brightness setting will enable you to see a full range of brightness tones. Windows users will find a screen calibration application in the Control Panel. Mac users will find theirs under System Preferences > Displays > Color. Both are user-friendly and achieve the same thing. Run them and follow the on-screen instructions every few months; screens change over time, and it is important to keep things looking neutral. It is also good practice to look at a plain and simple background while calibrating your screen.

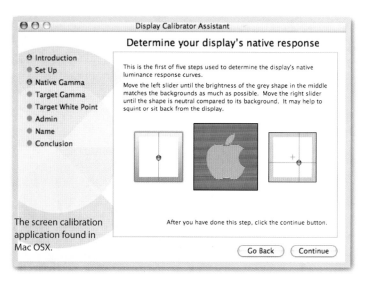

The screen calibration application found in Mac OSX.

Screen calibration devices

The main problem with calibrating a screen using the Windows or Mac OSX colour control panels is that this is a subjective process, relying as it does on the user's eyesight. Getting more consistent results requires a calibration device, such as the one from Pantone shown below. These devices work by sitting on the screen and watching a series of coloured squares as they are displayed. Some measure the intensity and temperature of the room light too and compensate for this.

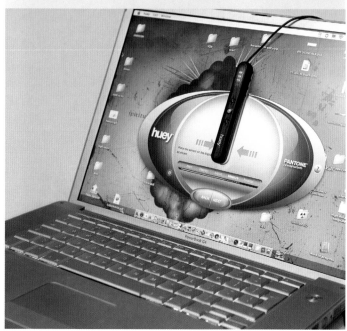

Alternatives to Photoshop

Most of the examples in this book are carried out using Photoshop, but other software could do the job, too. I chose Photoshop to demonstrate techniques in this book because it is so widely used and can do so much with its fully featured specification. However, the principles of digital photography – reading histograms, making exposure adjustments and sharpening, for instance – can equally well be carried out in other image-editing software, such as Paint Shop Pro or Microsoft's Digital Image Suite. The precise details of how commands work, and in which menu they are located, may be different in these programs, however.

There are alternative image-editing programs to Photoshop.

Left: Achieving accurate colours that reproduce faithfully on paper as well as on other users' computers is a complex process, but you are half-way there if you calibrate your display using the control panels built in to Windows and Mac OSX.

Working with Raw files

If your camera can shoot Raw files, you have the opportunity to take your photography to the next level, taking control of all the adjustments your camera normally does for you automatically. When shooting a JPEG image, most cameras take the data from the sensor chip and process it to form an image containing pixels of various shades of colour. They adjust the contrast, colour saturation and white balance according to the controls set on the camera before applying some sharpening and finally saving the result as a JPEG file with a specific amount of compression. Setting a camera to Raw mode switches off all of this

Below: The quality difference between JPEGs and the superior Raw files are not always noticeable without looking closely, but they are apparent, especially in areas of smooth continuous tone.

functionality, meaning you can work on the file yourself afterwards on your computer.

So, why would you want to do this? There are two reasons: flexibility and image quality. Raw files are very forgiving of mistakes in exposure and extremes of contrast. It is perfectly possible to recover at least 1.5 stops of under- or overexposure in a Raw file (and maybe even more if you're lucky), whereas with a JPEG file you will notice a deterioration in quality after 0.5 stop. It is also possible to tweak factors such as colour saturation and sharpness much more finely than you can in camera, so you can be more subtle and apply the right effect to the right subject.

Raw files also offer better image quality. JPEG files are artificially compressed to reduce their file size, enabling more of them to fit on a memory card. However, this compression results in a loss in image quality (in fact, this process is know as 'lossy' compression). Shooting a Raw file preserves all the quality in an image.

Raw – the pros and cons

There is one major disadvantage to shooting Raw, and it is an important thing to understand. Raw files are not image files. This may sound bizarre, but Raw files are literally just that: files containing raw information straight from the pixels in the sensor. All these pixels know about is brightness – they can't even see colour (tiny red, green and blue filters dictate which colour a pixel is sensitized to). Their content must be mixed together and processed to form an image, much as a latent image on a strip of film must be developed to form a negative.

The processing is carried out using special Raw-processing software that is usually, but not always, included with your camera. Alternatively, if you have Photoshop installed on your computer, you have a very powerful and flexible Raw converter at your disposal. Camera Raw is Adobe's Photoshop plug-in, and lets you open Raw files straight into Photoshop as if they were JPEGs. And this isn't the only option, either. There are many excellent Raw conversion applications on the market, ranging from the cheap and cheerful to the hugely expensive. Some are easy to use and uncomplicated, designed as they are just to convert files with the minimum of fuss. Others are fully featured, having well-designed workflow-based interfaces and features that really let a photographer go to town on their Raw files. Some even let you shoot with your camera connected to your PC or Mac, so the software converts the files as they come in. We'll look at some third-party applications on page 22.

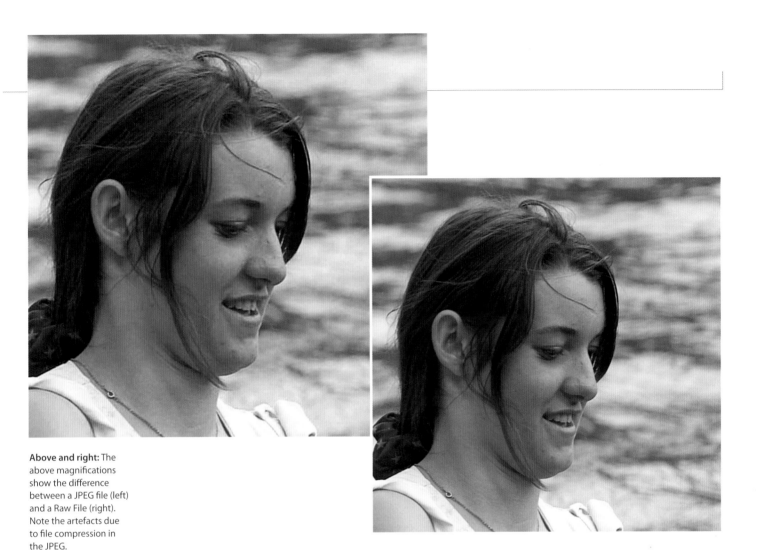

Above and right: The above magnifications show the difference between a JPEG file (left) and a Raw File (right). Note the artefacts due to file compression in the JPEG.

New camera? New Raw format?

The format of a Raw file is specific to the camera and manufacturer it came from. This is because the computer doing the processing needs to know all manner of technical information about how the camera is constructed (the size of the sensor and thickness of the infrared filter in front of it, for example), and this varies from model to model.

This means that Raw-processing software needs to be upgraded as new digital cameras appear on the market. Most camera manufacturers issue periodic updates over the Internet, as do the writers of third-party applications.

Be warned, however, that Adobe's update policy for the Camera Raw plug-in has come under fire from owners of previous versions of Photoshop. Only the most up-to-date version of Photoshop (currently CS2) is supported, meaning owners of CS or Version 7 are unable to convert files if they buy a new digital camera and are forced either to upgrade or to find an alternative solution. See www.adobe.com/cameraraw for more about Camera Raw, including which cameras are currently supported by the latest version of the plug-in.

If you obtain a new digital camera, you will need to update your Raw software.

Photoshop CS2's Camera Raw

Adobe's Camera Raw – the plug-in that is built in to Photoshop for opening Raw files – has gone through some changes since its introduction in Photoshop version 7. It has developed from a basic file-translation plug-in to a fully fledged piece of Raw-conversion software that is both flexible and capable of producing high-quality results. It can batch-convert files, apply one group of settings to a whole directory of other Raw files, and even perform basic editing tasks such as straightening and cropping. We'll look at some of these advanced features in Chapter 6, but for now let's examine the anatomy of Camera Raw and see what the various controls do.

01 These five sliders dictate the tonal look and feel of the picture. They are best used in the order they are presented in here, starting with Exposure and ending with Saturation. The Exposure control sets the highlights (the right end of the histogram), while the

Shadows control governs the shadows (the left end of the histogram). Brightness can raise or lower the overall brightness without clipping highlight or shadow detail (i.e. moving it off the end of the histogram).

02 One of the benefits of Raw is being able to set the white balance in a picture retrospectively. This can be done in Camera Raw by using one of the presets from the dropdown menu or by adjusting the Temperature or Tint controls. The former adds or subtracts blue or red, and the latter controls the level of magenta or green in the picture.

03 When a collection of settings is working well, it is possible to save them for future use by choosing Save from the Palette menu (click the small triangle in a circle). The dropdown Settings menu contains useful options to use the previous conversion's settings, or to reset all options to the camera default.

04 These three options dictate how the changes made with the tonal and white balance controls are seen. With the Preview box ticked, any changes made

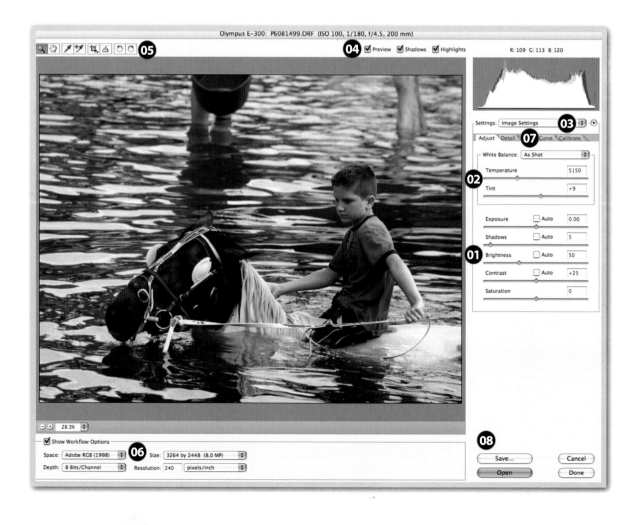

will show up in real time. The Shadow and Highlight warnings show areas of the picture that are clipped (i.e. they are so dark or light that they show no detail). In this example, an area of blown highlight is shown in red; featureless shadows are coloured blue.

05 With these basic editing tools, it is possible to rotate the image, straighten it and crop it. The White Balance tool is particularly useful for setting white balance by clicking on a neutral area of the picture.

06 The Workflow options govern the state of the picture as it is converted to an editable file. This includes what colour space the image is in (we'll look at colour space on pages 110–111; for now stick with Adobe RGB (1998), unless you know what you're doing), as well as its colour depth and resolution.

07 Explore the other tabs and you'll find yet more ways to adjust your image. The Detail tab, for example, offers three controls: Sharpness, Luminescence Smoothing and Color Noise Reduction. All digital images need sharpening at some point, and the Sharpness control dictates how much of this is applied at the Raw conversion stage. Many digital practitioners like to leave sharpening until later, however, applying it only as the last stage in the digital workflow. If you want to do this, pull the Sharpness slider down to 0 to ensure no artificial sharpening is applied at this stage. The Luminescence Smoothing and Color Noise Reduction controls are part of Camera Raw's noise-reduction system, and come into play when you want to get rid of the horrible blotching that affects picture taken with high ISO settings. Color Noise Reduction diminishes the occurrence of random areas of red, green or blue in a picture. Luminescence Smoothing reduces what is called chrominance noise, which has a finer, more speckled, appearance. Camera Raw's other features include a control to correct for common lens faults, such as vignetting (shadowing towards the outside of the frame) and aberrations (coloured fringing along high-contrast edges).

08 When you are happy with the preview of the picture, clicking Open will open it into Photoshop, whereas clicking Save will let you save it as a file for editing later on. Clicking Done will close Camera Raw while remembering the settings you have chosen for the particular picture. Selecting Cancel will do the same but reset all adjustments to their original values. Holding down Alt (or Option on the Mac) gives the option of resetting all values without closing the file – this is useful if you find yourself in a muddle!

Focus on... updating Camera Raw

Updates to Camera Raw are available free of charge from the Adobe website at www.adobe.com/cameraraw. These are issued periodically when new cameras – and hence new Raw file definitions – are released on to the market. When you have downloaded a new version of the plug-in, you will need to find the right place to install it on your hard drive so all Adobe programs can see it, not just Photoshop (Bridge, for example). For Photoshop CS2, the Camera Raw plug-in lives in the following locations:

• Windows – program files/common files/adbobe/plug-ins/cs2/file formats
• Mac OSX – library/application support/adobe/plug-ins/cs2/file formats

It is good practice to move the old version to another location for safekeeping, rather than deleting it, just in case you need to go back to an earlier version for any reason.

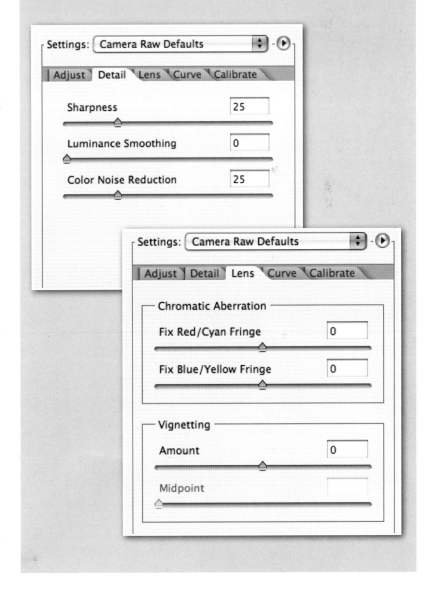

Third-party Raw converters

The Photoshop/Camera Raw combination is not the only way of working with Raw files. Several standalone applications are available that can process a digital camera's Raw sensor information and turn it into an easily readable image file. Some of these applications even do a better job than Camera Raw, having more features and a more efficient user interface. Take Capture One from the Danish manufacturer Phase One, for instance.

This software was originally developed to work with Phase One's medium-format digital camera backs, but now converts files from most digital single-lens reflex cameras. It has a workflow-based interface, meaning the photographer follows a path from selecting the file, through adjusting white balance and exposures, to queuing the file for processing, which happens behind the scenes so other pictures can be worked on without having to wait.

Other notable software packages include Bibble (www.bibblelabs.com), which tackles digital noise very well; DxO Optics (www.dxo.com); which can correct for lens distortion at the same time as processing the files; and Picasa (http://picasa.google.com), which has the bonus of being free. Also check to see whether the software that came with your camera suits your needs. Some manufacturers' approach to Raw conversion is better than others, but it is always worth a try.

A new approach to Raw files

A new approach to working with Raw files has gained popularity with the release of software such as Aperture from Apple and Lightroom from Adobe. These applications handle Raw conversion in a very different way, letting users edit an image without the need to convert it, and saving the changes in a database. The upside of this non-destructive approach is that the original Raw file is never physically changed; every time an image is opened, any changes already made to it are reapplied in real time. The downside is that this requires a very fast computer to work seamlessly.

Right: Capture One software is a professional package designed around a workflow approach to Raw processing. It can batch-convert a large number of files while the photographer continues to work on other tasks.

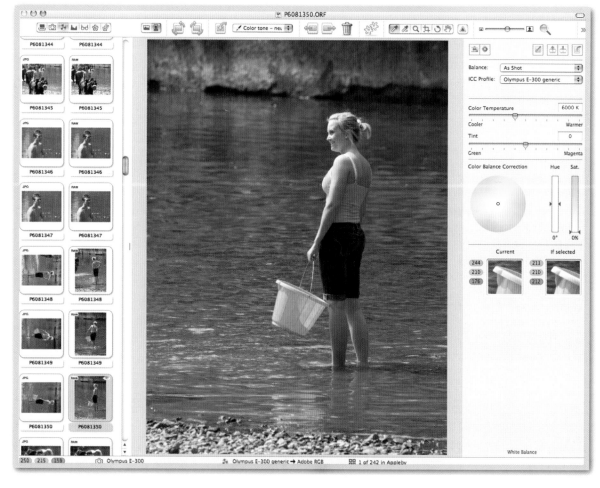

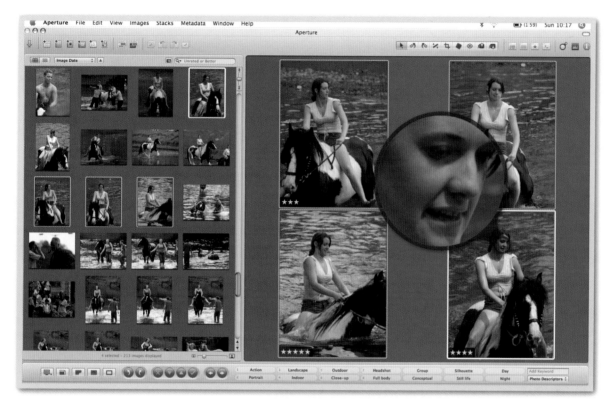

Left: Non-destructive editing of Raw files, without the need to convert them to another type of file, is possible in applications such as Apple's Aperture.

Focus on... Raw files

Why is that Raw files offer so much more exposure latitude than JPEG files shot in the same camera? The answer to this lies in some rudimentary mathematics. A normal TIFF or JPEG file is what is called '8-bit' in computer circles. To the rest of us, this means that it has 2^8 (in other words, 256) brightness levels, which is enough to give us a good range of tones in a photograph, should everything be okay. However, most digital cameras use a 12-bit sensor – in other words, the camera can 'see' 2^{12}, or 4,096, brightness levels.

When shooting in JPEG mode, a digital camera ditches the extra information that the 12-bit sensor sees and keeps just the 256 brightness levels it thinks correspond to the correct exposure. In a Raw file, however, this extra information is retained, and can manifest as a wide exposure latitude for photographers to exploit during processing.

It is often possible to recover two stops of exposure error from Raw files without a noticeable drop in image quality.

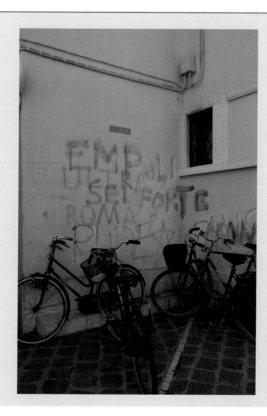

Organizing files with Adobe Bridge

With Photoshop CS2 came Bridge, a standalone application that evolved from the file browser built in to previous versions of Photoshop. It is now a much more sophisticated application and can do much more than simply show thumbnails.

Bridge can be run from within Photoshop (it has its own button on the toolbar) or separately, without Photoshop even being open. In its standard guise, Bridge lets a photographer view thumbnails of all kinds of media files (not just images), add data to them, such as the location of a picture and any copyright information, and even rank and label them according to quality or suitability. Bridge can even work with Camera Raw to process Raw files without having to open Photoshop, and can automate tasks such as building web galleries and putting together contact sheets. Let's look at the anatomy of the application and explore just some of the things it can do.

01 The thumbnails section is the main area of the application, showing all files present in the currently active directory. Clicking once on a thumbnail makes it active and means that the information associated with the picture can be changed. For instance, click on one of the five dots underneath a picture to add a star rating based on how good you think the shot is: five stars for a good image, one star for a poor one. The size of the thumbnail can be changed with the slider on the bottom right, as can the view type.

02 Navigate the directories and disks on your system here, and add any frequently used locations to the Favorites tab to make finding them more speedy.

03 The Preview pane shows a larger image than thumbnails do and is useful for checking details. It can be made bigger or smaller by moving the lines that divide the pane from the File Structure and Keywords pane.

04 The Metadata/Keywords pane holds information

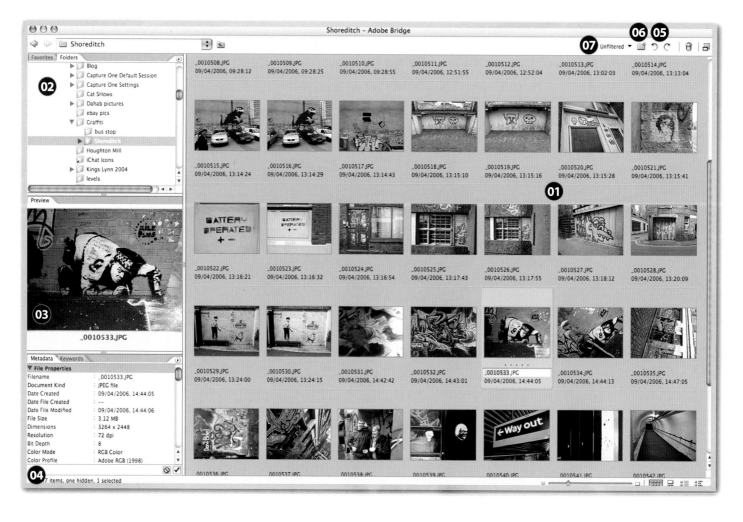

about the picture. Some of it will probably already be there – the aperture, shutter speed, ISO, zoom setting and date are recorded by most digital cameras – while other information can be added afterwards. It is useful to write a short description of the image in the caption field as a memory aid.

05 These tools can be used to rotate any images that are the wrong way around. Bridge doesn't change the file when it does this; it simply rotates the preview and remembers to tell Photoshop to do the same on opening the file properly.

06 Create a new folder with this button when you are organizing your images into categories.

07 The Filtering menu contains options to show and hide specific files, such as those with only a certain start rating or label.

08 Alternative views, selectable from Bridge's Window menu, make working in specific ways easier. Lightbox view gives emphasis to thumbnails, for instance, while Metadata Focus makes adding and reading these details a breeze.

The functions of Bridge

Printing a contact sheet is a good way of seeing thumbnails at a glance.

You can use Bridge to carry out the following functions.

• Process Raw files
Select the file by clicking it once and choose File > Open Camera Raw. The familiar Camera Raw plug-in will open, where you will be able to make any changes and adjustments. Then click Open to open the file into Photoshop, or Save to save it without opening Photoshop at all.

• Create a contact sheet
Select those files you want to include on the page (Ctrl- or z-clicking lets more than one file be selected) and choose Tools > Photoshop > Contact Sheet II. Photoshop will open with the Contact Sheet dialog box in which you can specify settings.

• Rename a large number of files
Select Tools > Batch Rename and specify the format and content of the new file name in the box that pops up.

• Preview images full screen
Select View > Slideshow. The screen will dim and each image will be shown full size against a black background. Hit the forward and back cursor keys to flip through the images, or H for more options.

Digital Asset Management

If you are serious about workflow, then sooner or later you will need to consider a Digital Asset Management (DAM) application. As handy as Bridge might be, it has its shortcomings – chief among these being that it isn't a true image database, which limits its performance and features.

DAM applications are databases that catalogue your images, making huge collections of images searchable in an instant. They also help you to organize multiple versions of the same image, for instance if black and white versions of a picture exist as well as colour ones, or if there are different compositions and crops.

There are a number of DAM applications to choose from, and as workflow becomes more important to digital photographers this is set to rise. Market leaders include Microsoft's iView MediaPro, Extensis Portfolio and ACDSee. Let's look at the anatomy of iView MediaPro, and how it can be used to keep track of a set of images.

01 Thumbnails in the main window can be browsed and star ratings assigned to determine which pictures are to be taken further in the workflow and edited in Photoshop.

02 Assign keywords and other metadata such as event titles or people's names in the Catalog Fields box. It is possible to search on this information or use it as a filter for viewing just those files of a specific type.

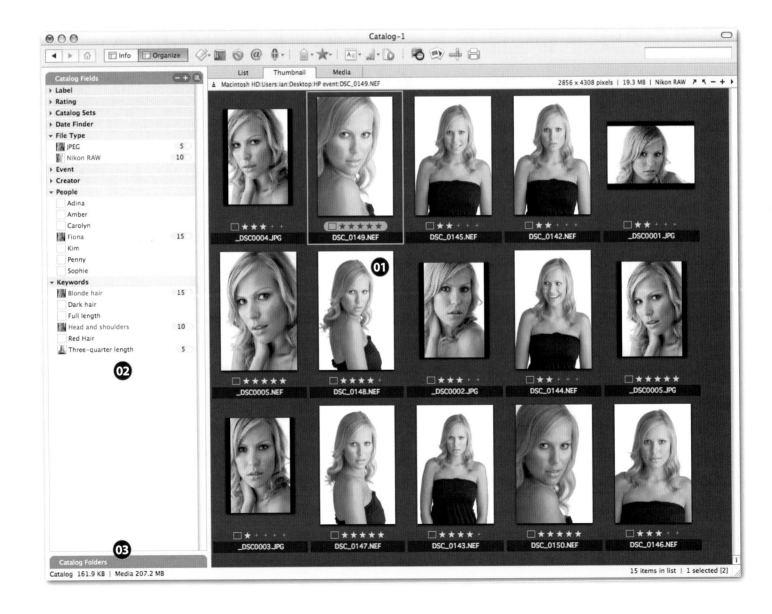

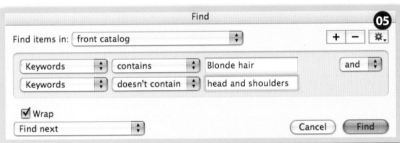

iView MediaPro is one
of the most useful DAM
applications currently
available.

03 Notice that even though this catalogue contains
more than 200MB of images, it is only a few hundred
KB itself. Larger catalogues of some 5,000 images
typically occupy just 50MB of space; this is what
makes DAM applications so fast to use.

04 In Lightbox view it is possible to view images full-
screen without the distraction of menus and toolbars.
iView MediaPro can also show more than one image
at a time, making comparisons easy.

05 Searching is one of the main reasons for working
with a DAM application. Imagine being able to search
through thousands of photographs for very specific
criteria – for instance, head-and-shoulders shots of
blonde-haired women taken in the last twelve months.

06 Your camera records extremely detailed picture
information when an image is shot. DAM applications
access this and allow you to add your own details too.

Left: Some photographers still shoot with film because they like the look it gives their images. When working with film, scanning becomes an essential part of the digital workflow.

Below: Cleaning a transparency before scanning it is essential.

Scanning

With photographic shop windows now crammed full of digital cameras, you would be forgiven for thinking this is the only way of working with digital images. Scanners have been around for longer than digital compacts and SLRs, however, and they are an important way of working with digital images.

Anyone who has a back catalogue of images shot on print or slide film will be interested in scanning – perhaps for archival purposes, or maybe to revisit shots taken before it was possible to manipulate them digitally. And the days of film are not over, either. There still isn't a digital camera available that can produce an image superior in quality to film; many professional photographers still shoot on film for the distinct look they achieve, only going digital later on with high-resolution scans of the processed negatives or transparencies.

Scanning for many photographers involves a flatbed scanner. These devices can cope with prints, negatives and slides. If you are in the market for a scanner, think carefully about what kind of media you will be digitizing.

If you have a lot of negatives or slides then you may be better off with a dedicated film scanner as the results it will produce will be vastly superior to a flatbed.

All scanners come supplied with software to control the hardware from your PC or Mac, but you are not stuck with this if you don't get on with it. Third-party scanning software, such as VueScan (www.hamrick.com) or SilverFast (www.silverfast.com) can control most scanners and can provide as much, if not more, functionality than the scanner manufacturer's own application.

Keeping things clean

Cleanliness is a very important part of the scanning process. Although it is easy to touch up the effects of any dust particles in Photoshop, it is much quicker to give your media and scanner a blast of compressed air and a wipe with a brush to ensure that everything is clean in the first place.

Many scanners have dust-reduction facilities built in to them. Digital Ice is one such piece of anti-dust technology. It works by shining infrared light through a negative or slide to pinpoint where the dust is. A software algorithm then tries to eliminate any foreign bodies from the scan. It works, but again, nothing is a substitute for a clean set-up – especially as this type of dust reduction does not work on black and white film, where it is often most needed.

Right: A versatile flatbed scanner can scan negatives, slides and prints.

Successful scanning

• Keep it clean
There is no better way to achieve good scans than to work in a dust-free environment. Keep all prints, negatives and transparencies in their protective sleeves when not in use.

• Take control of exposure
Most scanners will try to set exposure and white balance automatically, and most of the time this will be fine. However, watch out for any blacks that don't quite look black or whites that aren't as bright as they could be. Getting it right at this stage is much better than having to fiddle around with an

adjustment such as Levels or Curves in Photoshop later on.

• Not too sharp
Scanning software can apply an artificial sharpening process to the scans being saved from your scanner. Although it might be tempting to use this feature, it is much better to save all sharpening until the end of the digital process, when all other editing and manipulation is complete.

• Go Standalone
Scanning directly into Photoshop via a plug-in is convenient, but it does stop

the application from working while the scan is carried out. Using the scanner software as a standalone application is a much better option. It will take only around ten per cent of your computer's processing power, leaving plenty left for you to carry on working in Photoshop while a scan is taking place.

• Use your scanner's best bits
Let your scanner warm up, as optics and bulbs perform at their best when at their correct operating temperature. Flatbed scanners also give their best image quality in the centre of the glass, so stay away from the edges if you can.

Basic adjustments

Ask any traditional darkroom practitioner what they value most about developing and printing their own images and they will probably enthuse about the control they have over the brightness and contrast of their prints. But with all the control that Photoshop users have over their images, digital photographers have never had it so good.

By understanding how a photograph's various brightness levels are distributed, it is possible to manipulate the tones and colours in that part of the picture. This is a simple enough concept. However, there are so many ways of manipulating a picture's shadows, highlights, midtones, contrast, colour balance and saturation that things can start to appear intimidating. The important thing to remember is that everyone has their own way of doing things. If simple adjustments using basic Brightness and Contrast controls work for you, then that's great. Keep using them and progress on to more sophisticated methods later.

For most photographers, tweaking brightness and contrast comes into its own when mistakes in exposure need to be corrected. Giving a specific look and feel to your pictures is crucial when putting your own unique stamp on your work. There are many ways to do this, especially if adjustments are combined and used together. For example, colours can be enhanced to super-bold levels by increasing the colour saturation and contrast in an image. Or you can achieve a completely different (but equally effective) look by decreasing the colour saturation and increasing contrast.

One of the most important skills that a Photoshop practitioner can have is the ability to isolate specific areas of an image, so that adjustments are made only to this area. These areas – or selections, as they are known – can be created in a variety of ways, whether it is by simply tracing around shapes with a Lasso or Marquee tool, or by creating complex masks so areas of faded or partial selection can be made. We will frequently come across the need to use selections during this book, so it is worth making sure you understand the concept.

There are areas of digital imaging that film photographers never had to worry about – sharpness, for example. This is something we all strive after, but were you aware that it is possible to have a digital image that is too sharp? Don't be daunted – we will look at sharpening and explain how to apply it for the optimum effect. With this and other basic adjustments under your belt, you will soon realize that the possibilities for the digital photographer are truly endless.

Exposure

Exposure is one of the fundamental principles of photography. It is defined as the amount of light reaching the sensor and is governed by how long a camera's shutter opens (the shutter speed) and how wide it opens (the lens aperture). These days, camera metering systems are super-intelligent and can assess the brightness of almost every scene correctly. However, for that small percentage of situations when your camera gets it wrong, it is useful to be able to spot this and correct it – either at the time or afterwards when editing your pictures in Photoshop.

There are many reasons that a camera (even a very modern one) can get an exposure wrong. If a scene is dominated by black, a camera may overexpose (let more light in). Likewise, if a scene is dominated by white, underexposure (letting less light in) may occur. In practice this might mean photographing someone's portrait against a dark black background or a bright sky.

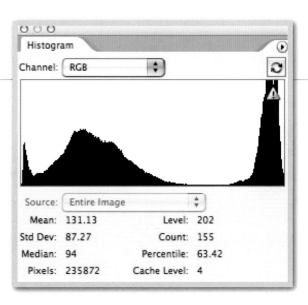

Focus on... histograms

Histograms can be found in-camera, and can tell you whether an image has been well exposed or not.

Many digital cameras show the histogram of a picture when they play back pictures, and some even display as a scene is being composed. It is more accurate to use this to determine whether your exposure is correct than to trust how the picture looks on your camera's review screen. Images often appear darker than they are in strong outdoor light, and you may end up correcting for a situation that doesn't need it.

Reading histograms

Histograms are a relatively new aspect of photography, as they came about only with the advent of digital cameras and scanners. Put very simply, a histogram is a bar chart that shows the relative amounts of each brightness level in a picture. The examples on the opposite page show the range of tones in a picture of a street scene in Egypt.

The key to reading a histogram is to imagine that the horizontal axis is labelled 'pixel brightness', with 100 per cent black represented at the left-hand end of the axis and 100 per cent white at the right-hand end. If you could zoom in closely enough, you would see that for each of the 255 brightness levels ranging between pure black and pure white there would be a column whose height represented the number of pixels of shade.

In the example shown opposite, the centre histogram indicates correct exposure: the pixels are mostly found towards the middle of the chart. In cases of over- and underexposure this is not so. When an image is underexposed, the corresponding histogram will run off the left-hand end of the horizontal scale, as if the tones are darker than they should be, and any that have disappeared off the end of the histogram will be rendered 100 per cent black.

This situation is reversed for overexposure: the histogram will disappear off the right-hand end of the horizontal axis, and midtones will be shifted to brighter levels than they should be.

Viewing a histogram in Photoshop is easy; in fact, it has its own palette. If this is not showing, activate it by selecting Window > Histogram. As with all palettes (see pages 14–15), you can drag the histogram out of its group and view it on its own, or add it to a different group. You will also notice a small, black triangle in the palette. Click this and you will be able to select the Extended View, which shows the histogram of each colour channel individually.

Viewing each colour channel's histogram individually can be useful for correcting colour casts, as we'll see a little later on (see pages 38–39).

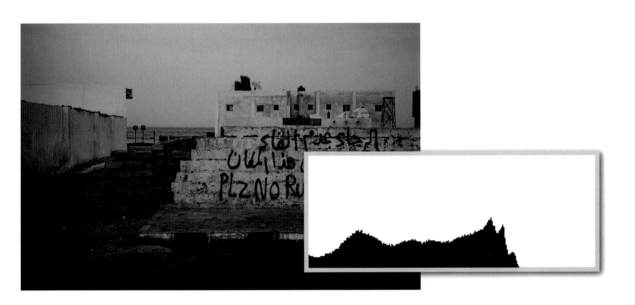

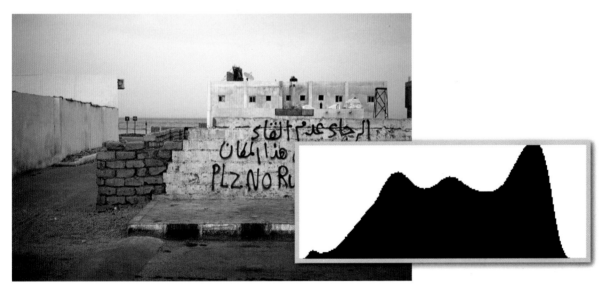

Left, top to bottom:
Underexposure (illustrated by the top image) is manifested by a shift of the histogram to the left, and clipping of the darkest pixels as they disappear off the left-hand side of the chart. Overexposure (shown in the bottom picture) causes the histogram to shift the other way, towards the right-hand end, with the lightest tones moving off the scale. Correct exposure (shown in the central image) will result in a histogram with most of the pixels grouped in the middle.

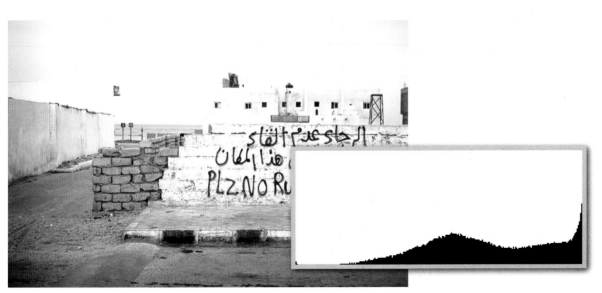

Correcting exposure

A histogram may tell you when a shot is under- or overexposed, but what if you don't have the opportunity to reshoot the picture, or you realize the mistake too late to do anything about it? Don't worry – almost all digital-imaging software offers a few ways to correct wayward exposures. Photoshop offers many ways to do this, ranging from the straightforward to the complicated. Let's look at some of the more common ones.

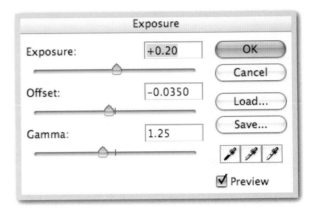

Right: The Brightness/Contrast dialog box and the Exposure control are just two ways of altering the brightness of a photograph.

Adjusting brightness, contrast and exposure

Perhaps the most user-friendly of Photoshop's many tonal adjustment tools are the Brightness/Contrast and Exposure adjustments. The former will be familiar to anyone who has dabbled with digital imaging before, while the latter is a relatively new addition, being new for Photoshop version CS2.

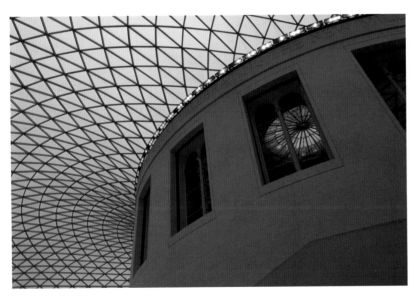

Above: This shot of the British Museum has confused the camera's meter, resulting in underexposure.

Right: A simple Levels adjustment can work wonders for pictures suffering from slight exposure problems.

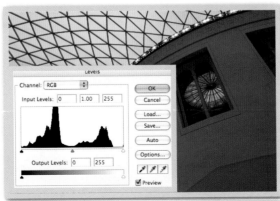

The Brightness/Contrast controls can be selected from the Image > Adjustments menu. They function pretty much as expected: the brightness slider affects the overall tones of the image, while the contrast slider darkens the dark tones and lightens the lighter ones. This is good for uncomplicated situations that don't require much correction.

The Exposure control (Image > Adjustments > Exposure) works somewhat differently: moving the Exposure slider affects the highlights while trying to keep other tones, such as midtones and shadows, unchanged. The Offset control does the same for the shadows, while the Gamma slider brightens or darkens the midtones. The Exposure tool was originally designed to work with High Dynamic Range (HDR) images, which we'll look at in Chapter 6, but it works well on normal pictures too.

Using Levels

The most intuitive way of making adjustments to a histogram is with the Levels tool. This mainstay of many digital photographers allows the black, white and mid-grey points on a histogram's horizontal axis to be redefined, thereby moving, stretching or compressing the tones in the image. This sounds complicated, but isn't really.

Select Image > Adjustments > Levels and a histogram will appear with adjustment points representing the image's shadows, midtones and highlights positioned along the bottom. These points can be dragged around to define which parts of the histogram correspond

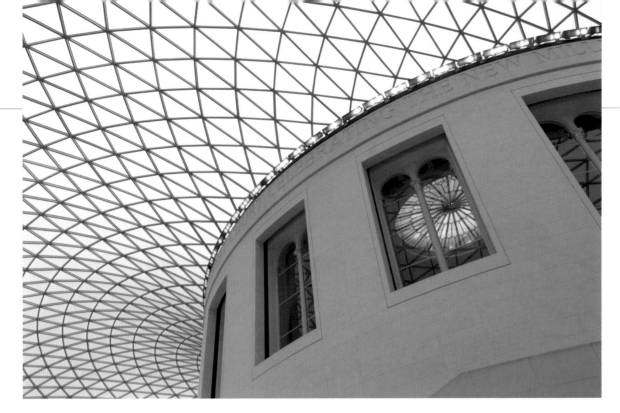

Left: The image after a Levels correction.

to which brightness level. Moving the shadow and highlight points is rather like moving the ends of the horizontal axis, which lets us fix the under- and overexposure we saw in the histograms on page 33. To fix underexposure, simply move the highlight marker in to meet the right-hand part of the histogram. If the preview box is ticked, you will see the effect this is having on the image in real time. Similarly, to fix overexposure, move the shadow slider in to meet the left-hand end of the histogram data. Once the shadow or white points have been moved, you may want to move

the middle slider too. This affects the brightness of the midtones in the picture. If you get in a muddle, you can always start again by clicking Cancel or holding down the Alt key (Option on the Mac) and clicking Reset.

Moving both the shadow and highlight points near to each other has the effect of increasing the overall contrast of the picture. By doing this you are darkening the darker tones and lightening the light ones – exactly what the Brightness/Contrast adjustment does, except that using Levels offers you a much greater degree of control and flexibility.

Focus on... Levels

Fixing exposure problems is as easy as moving the three sliders around relative to the histogram, but there is a quick way of setting the shadow, midtone and highlight points too. Using the three colour dropper tools at the bottom right of the Levels dialog box, it is possible to assign parts of the histogram to parts of the image simply by clicking on them. The right-hand colour dropper represents the highlights. Select it and click on the part of the image you think is the lightest in tone. The highlight point will jump to that place on the histogram in the Levels box. Similarly, clicking on the darkest part of the picture with the shadows colour dropper (the leftmost of the three) defines the part of the histogram that is 100 per cent black. The middle colour dropper, unsurprisingly, sets where the midtones lie, but it is important to realize that this is mid-grey. Clicking on a midtone that is slightly coloured will change the colour cast of the picture. This may seem unwieldy at first, but it can be useful for eliminating colour casts from pictures if a genuinely neutral midtone is present, as we will see later on when we talk more about colour (see pages 36–37).

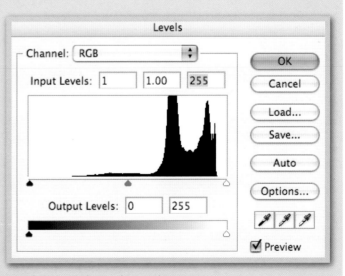

We will see the Levels control time and time again.

Colour casts

Colour casts can appear in pictures for all sorts of reasons – the type of light in which the photographer is working or the wrong white balance set on a digital camera are two common scenarios. Fortunately, correcting colour casts is relatively easy with image-editing software such as Photoshop and a basic understanding of how colours work together.

Using the Color Balance tool

The simplest way to correct a colour cast (or to introduce one, even) is to experiment with Photoshop's Color Balance command (Image > Adjustments > Color Balance). The idea is to move a slider away from a colour there is too much of, or towards a colour that is lacking. The Highlights, Midtones and Shadows options

Below: After colour correction, the warm electric light looks more like daylight.

dictate which tones in the image are affected by this adjustment, while the Preserve Luminosity tick box stops the overall brightness and contrast from changing.

Before starting to mess about with the colour, look for a feature in the image that is known to be neutral grey. Select the Eyedropper tool from the toolbox and Shift-click the neutral object. This should put down an information point, which will feed colour values to the Info palette (Window > Info). This is important, as without feedback you won't know when a neutral grey has been reached.

Select the Color Balance command and begin to adjust the sliders, all the time keeping an eye on the values in the Info box. Neutral greys have identical red, green and blue colour values, so try to get as near as you can to this for a truly neutral colour cast. Of course, this technique works only if you have a truly neutral grey in the picture; if you haven't, rely on your own eyesight and judgment, and make sure you have colour-calibrated your screen beforehand (see page 16).

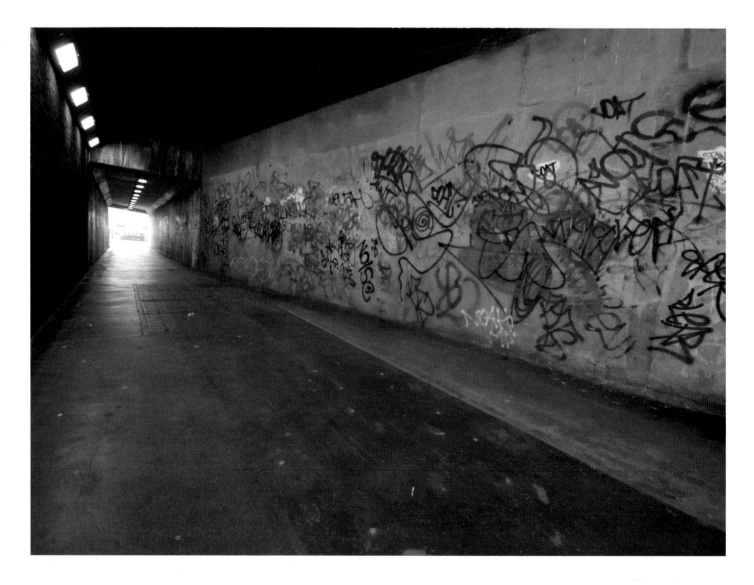

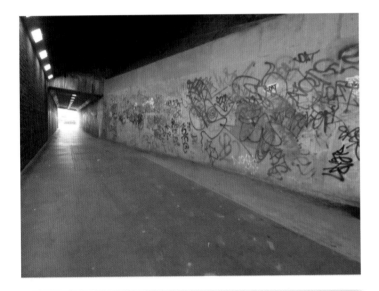

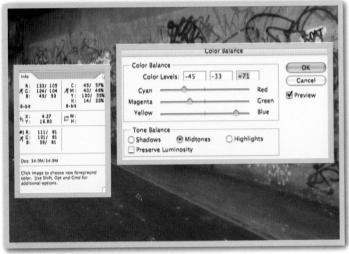

Top: The yellow-green cast in this picture is caused by the type of electric lighting used, but it is easily removed with Photoshop's Color Balance feature.

Above and left: Making a colour balance correction in conjunction with the Info palette gives an indication of the effect the adjustments are having.

Variations

It can be hard to picture which colour needs adding or subtracting for a neutral cast. Image > Adjustments > Variations offers a preview of the effect of adding a small amount of colour. Simply click on the thumbnail closest to the effect you want and hit OK. By selecting Highlights, Midtones or Shadows, you can limit the changes to a range of tones in the image. Moving the slider from Coarse to Fine decreases the amount of change shown in each thumbnail.

Photoshop's Variations function shows a preview of the adjustment that is about to be made.

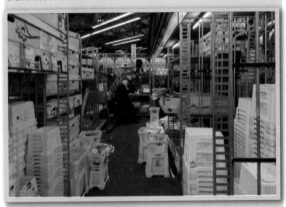

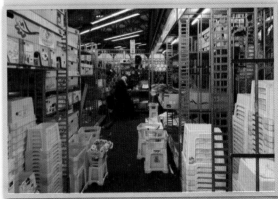

Using Levels to correct colour

On the preceding pages, we looked at Levels as a device for changing a picture's brightness and contrast. However, if you were curious enough to click the Auto levels button (or select Image > Adjustments > Auto Levels in Photoshop) then you will have seen that this can change an image's colour balance quite drastically. The effect is not very controllable (in fact, Auto Levels nearly always gets it wrong), but this does demonstrate that by tweaking the Levels of the individual red, green and blue colour channels it is possible to change the colour temperature of a photograph.

To understand how the colours that comprise an image work together, look at the colour wheel in the panel opposite. If an image has a cyan colour cast, for example, this can be removed by adding red. If an image has a red cast, this can be removed by adding cyan. This is because red and cyan are opposites (or

Below: Lighting this portrait with a domestic table lamp has given it a warm cast.

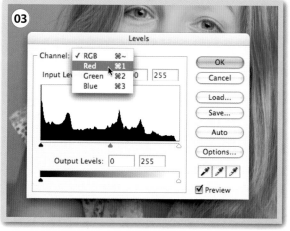

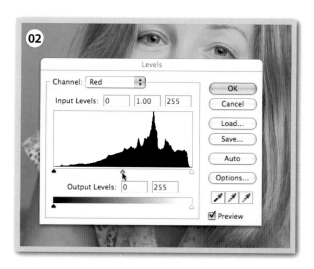

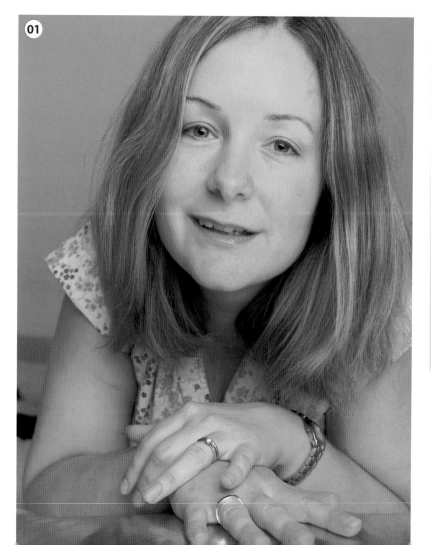

complementary), just as green is the opposite of magenta and blue is the opposite of yellow. You can apply this principle to Photoshop's Levels facility: making changes to the red channel will remove or introduce a red or cyan colour cast; changes to the green channel will affect green or magenta casts; and changes to the blue channel will introduce a blue or yellow cast. Let's see how this works in practice.

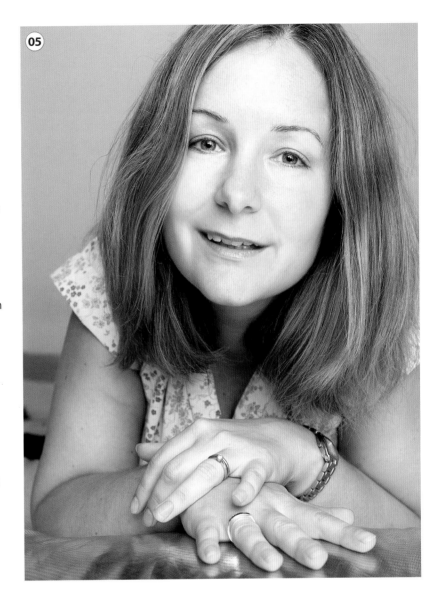

01 This portrait was taken using household tungsten lighting, which is warmer than daylight. We can correct this by making changes in the blue and red channels.

02 Bring up the Levels adjustment dialog box by selecting Image > Adjustments > Levels, or hitting Ctrl–L/⌘–L. To work on the red channel, select it from the Channel dropdown menu.

03 Moving the middle slider to the left adds a red cast to the image; moving it to the right takes a red cast away. Another way of saying this is that moving the middle slider to the right adds a cyan cast, while moving it to the right takes this away. Red and cyan are complementary to each other, remember?

04 Likewise, removing any traces of a yellow cast involves making changes to the blue channel. Select it from the dropdown Channel menu and slide the middle slider to the left (to add blue, or take away yellow, depending on how you look at it).

05 The final version, with pleasing skin tones now the colour cast has been dealt with.

Focus on... the colour wheel

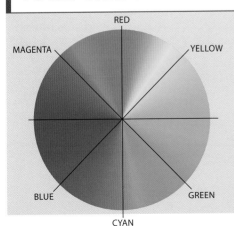

A typical colour wheel; complementary colours sit opposite each other on the wheel.

The colour wheel is a well-known graphical representation of the relationship between primary colours. Red, green and blue are known as additive primary colours, while cyan, magenta and yellow are known as subtractive primary colours. Each additive primary colour is opposite its complementary subtractive primary: red/cyan; green/magenta; and blue/yellow. Increasing the amount of any of the six primary colours reduces the amount of its complementary colour. For example, to alter the amount of magenta in a picture, change the values in the green channel; adding green has the effect of subtracting yellow. If this seems confusing, playing with an image's Levels will reinforce the principle.

Colour saturation

Adjusting the colour saturation is one of the most popular ways of personalizing an image. Some people like lots of colour; others like to be more subtle. Some subjects deserve a boost in colour (landscapes, for example), while others warrant a more gentle treatment (such as the skin tones in portraits). Photoshop offers a great deal of control in this area.

The most basic, and most popular way of adjusting colour saturation in Photoshop is the Hue/Saturation commands, which can be found in the Image > Adjustments menu. Select this, and you'll see a dialog box containing three sliders: Hue, Saturation and Lightness. It's the middle one that you tweak to control the boldness of the colours in your image.

It is important to realize that adjusting colour saturation on its own often doesn't give a natural result. It is better to tweak this in combination with an image's contrast too, using either a Brightness/Contrast or Levels adjustment. Popular combinations are low saturation and high

Below: Changes to contrast and colour saturation are best made together. These two properties are intrinsically linked.

contrast for a muted but punchy look, or a high-saturation, low-contrast look, with the reduction in contrast helping to bring some of the extreme colours back under control. With some investigation into how Photoshop treats the channels in an image, it is also possible to affect just one colour in a picture separately from the others.

The other sliders in the Hue/Saturation dialog box are brought into play less often, but do have their uses. Hue changes the colours in the image as the slider is moved along its scale. To the uninitiated, this may seem quite random, but the two rainbow bars on the bottom of the box give a clue to what is happening: the upper-most represents the colours before the adjustment is applied; the lower bar the colours afterwards.

The Lightness bar simply adds white or black to the colours in the image (or a select group of colours if these are selected using the channel menu – see panel opposite) depending on whether it is dragged to the left or the right.

Low saturation, low contrast

High saturation, low contrast

Low saturation, high contrast

High saturation, high contrast

Selective saturation

A benefit of working digitally is the ability to selectively boost the saturation of one colour over another. The dropdown menu in the Hue/Saturation dialog box allows one range of colours to be selected and its saturation to be increased or decreased.

The colour range across the bottom of the box is where this colour range can be tweaked and defined, either by dragging the sliders manually along the axis or by clicking on a part of the picture containing the colour that is to be manipulated.

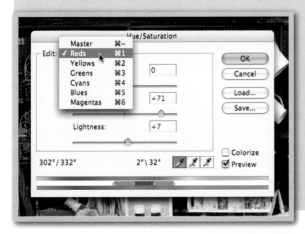

In this example, the colour saturation of the whole picture has been decreased, and then the reds brought back again to make the red watering can at the top of the frame stand out.

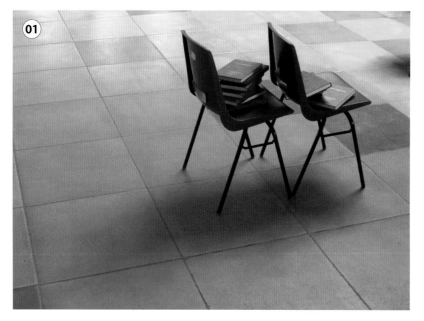

is shown by a flashing dotted line, often affectionately known as the 'marching ants'.

The most regularly used tool for making selections is the Lasso tool (sometimes known in other software as the Marquee tool). This is used to draw simple shapes around the parts of the image to be selected. It is quick and easy to use, but lacks some sophistication when it comes to very intricate work. Thankfully, a number of refinements have been built in to Photoshop over the years.

Sticking with the Lasso for a moment, the two variations of the tool – the Polygonal Lasso and the Magnetic Lasso – are exceptionally useful for drawing selection areas comprising entirely straight lines and for automatically tracing an edge, something that is useful when cutting elements out of one picture in order to drop them into another. The Magnetic Lasso is worth looking at in more detail.

The Magnetic Lasso

The Magnetic Lasso works by looking for the abrupt changes in brightness that indicate an edge. How much of a change of brightness it needs – a property known as Edge Contrast – can be specified in Photoshop's toolbar at the top of the screen, which is visible when the tool has been selected. A second variable, called Edge Distance, specifies how far from the mouse pointer the Magnetic Lasso tool will look for an edge.

Above: Changing the colour of just one floor tile involves first making a selection with the Magnetic Lasso.

Making selections

Much of the power of an application such as Photoshop comes from the ability to apply effects to just one part of a picture, and one of the principal ways to do this is to make a selection. This involves drawing round a part of the image with one of a number of tools; the part of the image that will then be affected

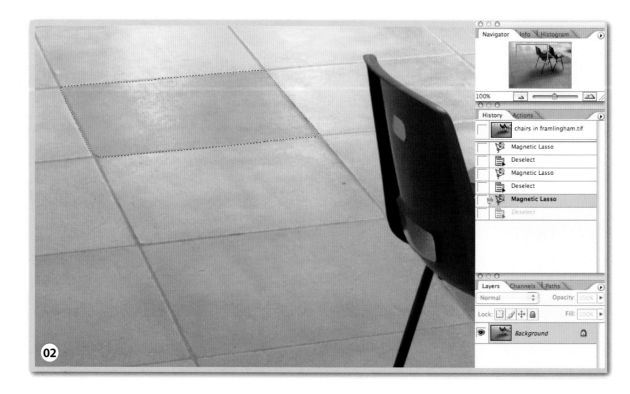

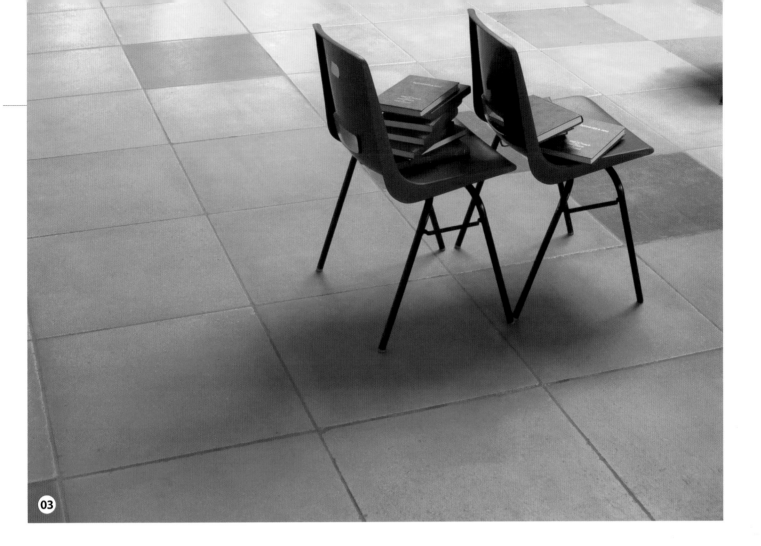

Tracing around an object using the Magnetic Lasso without the mouse button held down will draw a selection line that will occasionally snap back to what is considered an edge, and Photoshop will add an anchor point to keep it there. You can add anchor points manually if needed by clicking with the mouse, and remove an automatic or manual anchor point by hitting the delete key. How often anchor points are added automatically is determined by the Frequency, which can be set in the options bar at the top of the screen. You may find that using the Magnetic Lasso tool is easier with a graphics tablet and pen than a mouse.

01 To select just one floor tile in this picture we will use the Magnetic Lasso to trace around it, using an Edge Contrast of 5 per cent and a Width of 10 pixels.

02 Work slowly around the item in the picture, taking your time and letting the anchor points form automatically. To turn a tight corner, you may need to add an anchor point yourself, manually.

03 Once complete, you can use almost any adjustment tool or filter in Photoshop on just the selected part of the image. In this case, I used the Hue/Saturation adjustment to change the floor tile's colour.

Focus on... feathering

Making a selection with a lasso defines a very precise line – one side of it is selected, the other is not. This may be okay when a hard, defined edge is what is wanted, but in the majority of occasions, where this is not the desired effect, it is necessary to soften the boundaries defined by the marching ants. To do this, you must feather the selection.

Feathering is a way of phasing the transition between what is selected and what isn't over a number of pixels. It's easy to do: simply choose Select > Feather and enter the number of pixels to phase the selection boundary over. 5 is a good number for a normal edge. Increase this value if you want a really soft look. We will come across Feathering of selections often in the pages to come, and you should embrace it in your own work. It's an absolute must!

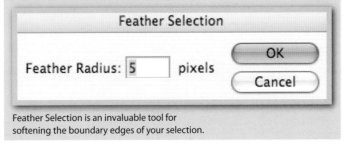

Feather Selection is an invaluable tool for softening the boundary edges of your selection.

The Quick Mask tool

We will look at Layer Masks later on (see page 49), but now is a good time to introduce a cut-down version of this concept that is invaluable when making selections. By engaging Quick Mask mode, any selections marked out with marching ants are coloured red. It is possible to add more selection to the picture using any of the standard brush and fill tools (and even the text tool). This not only gives more control over detailed selections of fine detail, but also allows for the partial selection of portions of an image using a semi-transparent brush. Leaving Quick Mask mode brings back the marching ants again, and returns the brush and fill tools to their normal use:

The Lasso tools and the Quick Mask work well together, and are not really competitors. Making a rough selection with a Lasso, and then tidying it up in Quick Mask mode is an efficient way of working, combining speed and accuracy.

Let's look at how making a selection with Quick Mask can help to preserve a part of this picture of London's

Below: The Quick Mask tool can be used to make detailed selections. Here, we isolated the red bus.

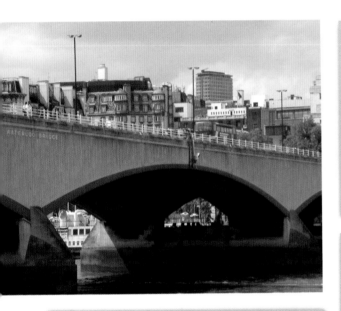

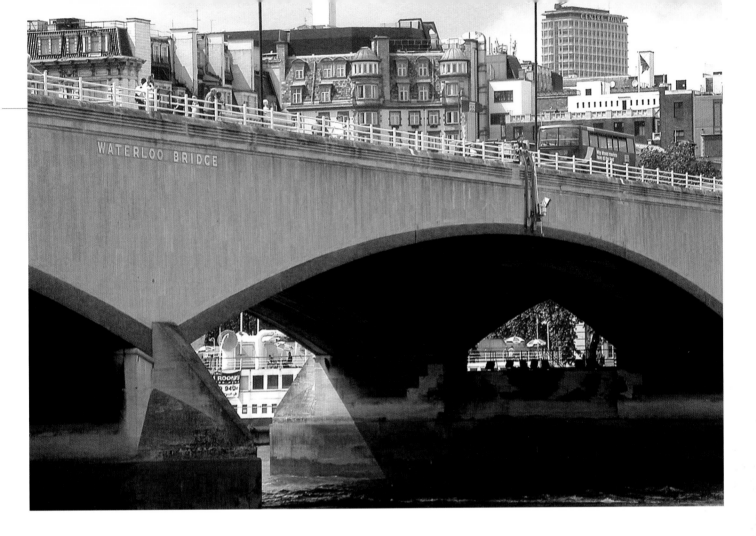

Waterloo Bridge in colour (the red London bus), while the rest of it is transformed to black and white – a good effect for emphasizing part of a scene.

01 After opening up the picture in Photoshop, I entered Quick Mask mode by clicking on its icon in the toolbox. To paint a Quick Mask over the bus, the Brush tool with a medium-sized brush from the Brushes palette has been used.

02 At a zoom level of 200 per cent, it is possible to see the bus in enough detail to begin painting around it with the Brush tool. The standard Quick Mask colour is red, but if you can't see this over the top of the object you are painting, you can change it by double-clicking the Quick Mask in the toolbox.

03 If you go over the edges of the object being masked, either select the Eraser tool or change the background colour to white and rub out the excess by painting over it.

04 When the object is completely covered, exit Quick Mask by clicking on the exit icon in the toolbox. You will notice marching ants surrounding the masked object, as shown here. If you zoomed out, you would see that everything in the picture is selected except the masked object. If the opposite situation is required, simply choose Select > Inverse Selection.

05 If you used a hard-edged brush you may need to feather the selection (Select > Feather); if a soft-edged brush was used to apply the mask then you won't. To transform the picture to monochrome, select Desaturate from the Image > Adjustments menu.

Above: The final image – part black and white, part colour.

Automatic selections

There are a few ways of making life easier when selecting portions of images in Photoshop. Tools such as the Magic Wand can select areas of a picture that are the same or a similar colour, and it is worth checking out the more sophisticated version of this tool too, Color Range (Select > Color Range).

The Magic Wand is perfect for photographs like the one shown below, where we want to make changes to the blue wall, but not the green tree or yellow pavement. Setting the correct options before starting to click away is important. Ticking the Contiguous box limits the areas selected to those pixels that are touching each other; unticking it means that every pixel in the picture with the same colour as the one clicked will be selected, regardless of whether they are touching or not.

Of course, there are millions of colours in a digital photograph, so chances are it won't be just one shade that is used to define a selection, but a number of them. Specifying a number in the Magic Wand's Tolerance box is how the width of this range is specified – a lower number makes the choice more specific; a higher number makes it more general.

The Extract tool

For complicated cut-outs, nothing beats the Extract tool for ease of use, especially where fine detail such as hair is concerned. Professional graphic designers often use this tool for cutting out models from a background in order to make text flow behind them – an effect that has graced many magazine covers.

01 The original picture.

02 Open the image to be cut out and choose Filter > Extract. In this dialog box, select the marker pen from the toolbox on the left and draw around the edges of the item being kept. Use a small brush for well-defined images and increase its size for complicated areas, such as hair.

03 Fill the completed selection with the Paintbucket to define the area to be kept and click Preview for a quick look at the final result. At this stage, the Clean-up and Edge Touch-up tools can be used to tidy any untidy edges. When you are happy, click OK to render the final cut-out.

04 Back in Photoshop, the cut-out object should be visible against a transparent background (defined by a grey checkerboard). If there are any areas of slight transparency in the cut-out, duplicate the layer a few times in the Layers palette. This is a great quick fix that works because drop-outs in the cut-out are usually only partly transparent. Layering them causes opacity in the area to add up.

Right: The Magic Wand selects pixels that are of the same, or similar, colours.

Right: Selecting just parts of an image means that certain areas can be colour- or contrast-enhanced while others are left untouched. This blue wall has been increased in saturation, for example.

01

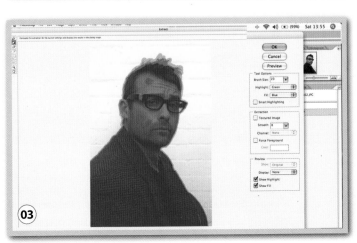

05

05 To add a new background, create a new layer (Layers > New > Layer) and name it 'background'. Reorder the layers in the Layers palette so the background layer is below the layer containing the cut-out, then, using the Paintbucket, fill it with your chosen background colour. Here, I've used a simple white.

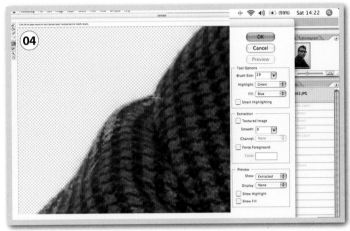

04

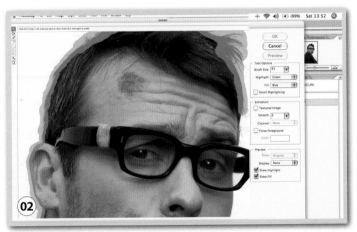

02

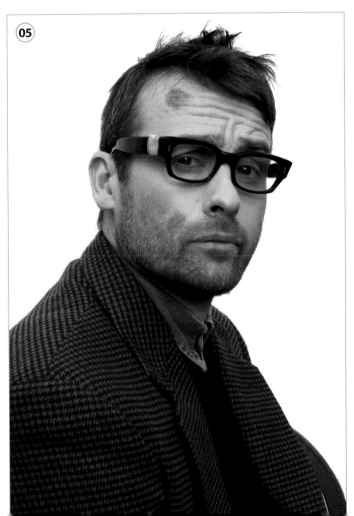

03

A digital neutral density grad filter

For years, landscape photographers have worried about how to expose for both the highlights and shadows in a scene. To the human eye, there doesn't seem to be a problem – looking at a landscape on a normal day, it is possible to see detail in both the bright sky and in the darker foreground. But our eyes work across a much wider brightness range than digital cameras do. This is why, when shooting landscape photographs, exposing for the foreground can result in a washed-out, overexposed sky, and exposing for the sky can leave you with an underexposed, dark foreground.

Traditionally, landscape photographers used graduated filters to lessen the contrast between sky and foreground. However, these are tricky to use, and if you get it wrong, there's no going back. In Photoshop, however, it is possible to mimic the effect digitally.

01 The original shot shows the problem: although the foreground is correctly exposed, the sky is burned-out and lacks detail.

02 I recognized this problem when I was still at the location and took a second frame exposing for the sky and letting the foreground underexpose. It is always easier to rescue underexposed parts of the picture than overexposed highlights.

03 The first step is to add a Levels adjustment layer (Layer > Add New Adjustment Layer > Levels, or use the shortcut in the Layers palette). This works in the same way as a normal Levels command, but the adjustments are all held in a separate layer and are editable.

04 Adjust the Levels according to the histogram until the foreground looks properly exposed. Don't worry about the sky at the moment; we'll fix that in a minute.

05 Making sure the Levels adjustment layer is active in the Layers palette, select the Gradient Tool from the toolbox and pick Foreground to Transparent from the menu of preset gradients at the top of the screen. Choose black as the foreground colour.

Below: The original image. The contrast between the sky and the foreground is too much for digital cameras to record. A little post-production in Photoshop is needed.

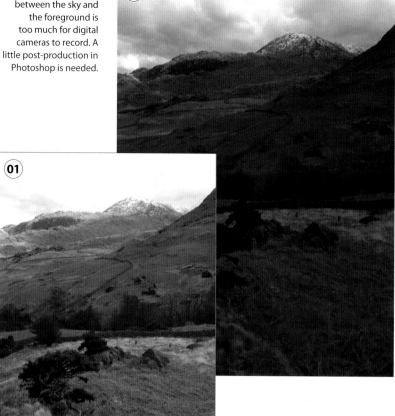

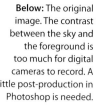

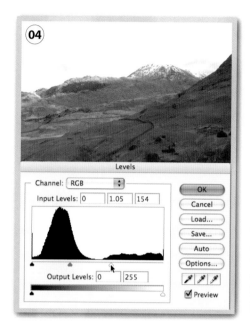

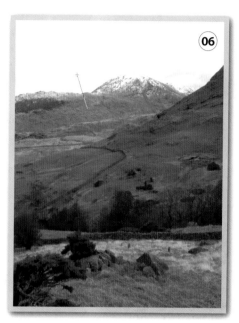

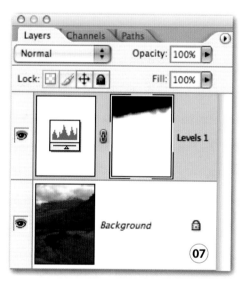

Right: The final image. A graduated neutral density filter can help reduce the difference in brightness between the foreground and the sky – as can some post-production Photoshop work, as shown here.

06 Now draw a line from the end of the bright sky to the start of the darker land. What you are doing here is creating a Layer Mask. This masks off part of the Levels adjustment so it has no effect on part of the picture. The line you have drawn marks the location of the transition between the opaque and transparent parts of the mask.

07 Look in the Layers palette and you will see a thumbnail of the layer mask with the parts that are masked off in black.

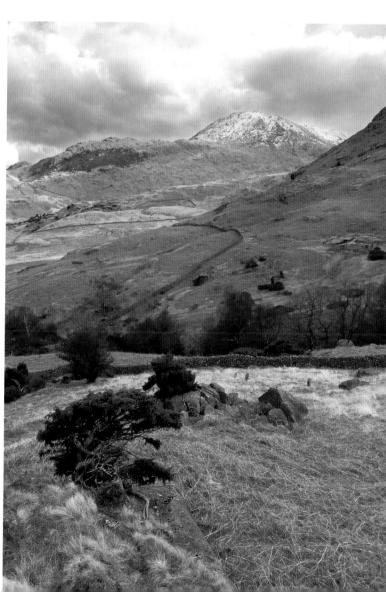

Cropping images in Photoshop

At some point, we all need to crop our images. Although this is one of the easier things to do digitally, it still pays to stop and consider the options available. There are two main routes towards cropping in Photoshop: one is to make a selection with the Rectangular Marquee tool and then selecting Image > Crop; the other is to use the application's purpose-built Crop tool to mask off parts of the image. This latter approach is the more flexible of the two, giving the photographer more control over what they are seeing, and how they choose the final crop.

The Crop tool is selected from the toolbox. At its most basic level, it is used to select those portions of the image that are to be kept. By default, the parts of the image not selected are masked off with a 50 per cent black mask so they appear dimmed. Once the selection is drawn it is possible to move it, resize it (by dragging the corner or side resize handles), or even rotate it (by positioning the cursor just outside one of the corner resize handles and dragging). If you want to resize the crop box while maintaining its shape (or 'aspect ratio'), simply hold down Shift to lock this in.

Specifying crops

It is possible to lock in a precise size and resolution for a crop by entering values in the toolbar at the top of the screen. Sadly, it is not possible to specify an aspect ratio here as Photoshop won't accept values without a unit, but as long as the resolution box is left empty an image won't be altered, and it can be resized later.

Below: This image can be cropped to form a number of different compositions, all the time placing emphasis on the lone tree.

Favourite sizes can be memorized for quick access by clicking the preset option in the top left-hand corner of the screen and choosing New Preset from the Palette menu. Common sizes are standard print sizes such as 6x4 inches or 7x5 inches, as well as square and panoramic crop ratios, such as 17:6.

Cropping doesn't have to be an afterthought. Next time you are out and about with your camera, think about how you might crop an image while you are looking through the viewfinder or composing on the camera's screen. If a square aspect ratio or long, thin panoramic crop suits your subject, make a note of it. This way you'll remember your intentions when you get home, and not dismiss the image as badly composed.

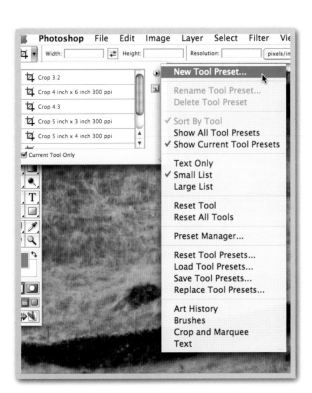

Above and top: The way a picture is cropped can change its mood and composition drastically.

Left: You can create presets for crop sizes that you use frequently in order to speed up your workflow.

Sharpening

Because of the way they are captured, all digital images need sharpening at some point. Sharpening is usually carried out in-camera the moment the picture is taken, although this automatic process takes a lot of control out of the photographer's hands. It is much better to turn off in-camera sharpening and apply it manually in your image-editing software later on.

Unsharp Mask

The most common method of sharpening a digital image is the so-called Unsharp Mask (USM). This digital filter derives its name from a traditional darkroom technique in which a blurred and a sharp image were combined to increase edge contrast and give a perception of increased sharpness. This is also how the digital version of USM works.

In most applications, USM has three controls: Amount, Radius and Threshold. Each does a specific job, but it is important to use them together to gain the full benefit from this essential tool.

• Amount
Once the USM filter finds an edge in a picture, which it defines as an abrupt change in brightness, the Amount parameter specifies how much the contrast from one side of the edge to the other is increased. A good starting value is 100 per cent.

• Radius
The Radius control determines how many pixels next to an edge pixel will be changed by the sharpening filter. The greater value, the more pixels will be affected and the more apparent the sharpening will be. The correct value for the Radius setting depends on the resolution of the image: a lower-resolution image requires a smaller Radius value than a high-resolution image, and the effect is much more noticeable on screen than it is on paper. A good guideline for finding a starting point is to take the output resolution of the image and divide it by 200. For a 300dpi (dots per inch) print, a radius of about 1.5 should work well. For 96ppi (pixels per inch) screen resolution, a value of 0.5 is nearer the mark. (See page 109 for more on resolution.)

• Threshold
USM finds edges by taking each pixel and looking at its neighbours to see whether they change abruptly in contrast. The Threshold specifies how different neighbouring pixels must be from each other to be classified as an edge and sharpened. For example, a value of 3 means that only adjacent pixels differing in brightness by three levels or more will be affected; pixels of brightness levels 198 and 200 would be left unchanged. Setting a threshold of 0 means the filter will affect all pixels in the image.

Note that, like all filters, the USM affects only the currently active layer, so an image comprising more than one layer should be flattened prior to USM being applied to the image.

Left: Unsharp Mask is one of the most commonly used methods of sharpening digital images.

Too much sharpening

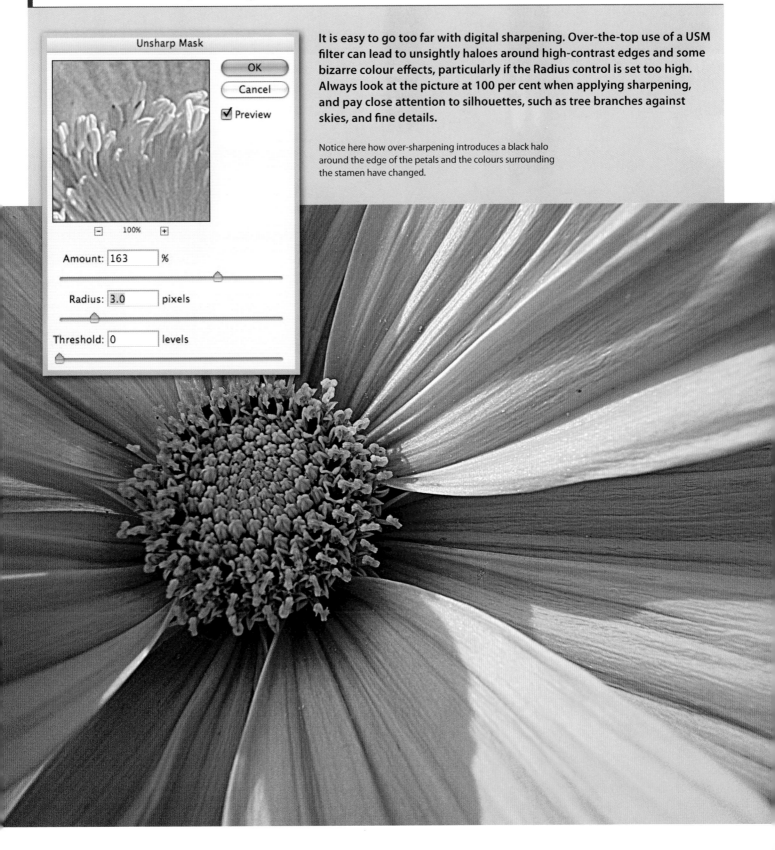

It is easy to go too far with digital sharpening. Over-the-top use of a USM filter can lead to unsightly haloes around high-contrast edges and some bizarre colour effects, particularly if the Radius control is set too high. Always look at the picture at 100 per cent when applying sharpening, and pay close attention to silhouettes, such as tree branches against skies, and fine details.

Notice here how over-sharpening introduces a black halo around the edge of the petals and the colours surrounding the stamen have changed.

Unsharp Mask

OK

Cancel

☑ Preview

□ 100% ⊞

Amount: 163 %

Radius: 3.0 pixels

Threshold: 0 levels

Smart sharpen

The USM is ubiquitous in digital photography and has been around for years. It can be found in your camera, your scanner and almost every digital photography software package on the market. In fact, the Smart Sharpen filter, which was introduced with Photoshop CS2, was the first refinement of the application's sharpening tools for years.

Smart Sharpen offers several advantages over USM. The first is that you can specify which kind of blur the filter looks for during the sharpening process. Choosing Gaussian from the dropdown menu effectively performs the same task as USM, but selecting Lens Blur forces the filter to sharpen only those parts of the picture that need it – the edges. Any areas of continuous tone, such as blue skies or painted surfaces, are largely left alone.

Above left: after sharpening with the Smart Sharpen filter.
Above right: The unsharpened image.

The second benefit is that the haloes that appear as artefacts of the sharpening process can be minimized by fading them, meaning a higher amount of sharpening can be used in those areas of the picture that really need it. These controls are accessible once the Advanced button is clicked. The Shadow and Highlight tabs contain, respectively, controls for tackling dark and light halo artefacts. The Fade Amount slider governs the amount of sharpening in the shadow/highlight areas – increase it and the amount of sharpening diminishes.

The Tonal Width and Radius controls dictate what is classed as a shadow or highlight – the former determines the range of tones to be considered and the latter specifies the area around each pixel that is evaluated by Smart Sharpen when it looks for artefacts.

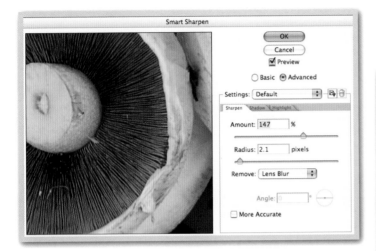

Left: The Smart Sharpen filter looks only at the parts of the picture that need sharpening: the edges.

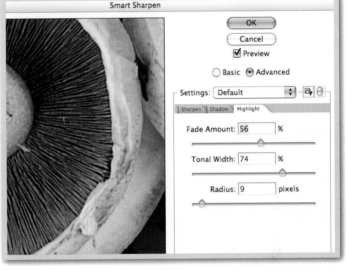

Right: Using these controls, the Smart Sharpen filter can be throttled back to avoid unsightly halo artefacts.

Focus on... sharpness

The term 'sharpness' can be broken down into two distinct terms: resolution and acutance.

• Resolution is the amount of detail that can be captured in a photograph. Although digital photographers are programmed to think about resolution in terms of the number of pixels on their cameras' chips, the resolving power of a lens is equally important in this respect.

• Acutance is defined as the change in brightness that occurs across an edge. The higher the contrast across an edge, the sharper it will appear. It is acutance that is enhanced by USM filters in digital-imaging software. It is important to understand this: sharpening filters cannot add anything in terms of resolution to digital pictures.

Resolution dictates how many of the pebbles on this beach we can see. Acutance governs how sharp they appear.

Borders and framing

Adding a border to a photograph is a good way of presenting it in its best light, whether this is on a wall or computer screen or in an album or book. The possibilities for doing this are limited only by your imagination, but it doesn't hurt to consider good taste when applying an effect too. The unwritten rule when framing a picture is that it should enhance a picture, not compete with it for attention.

A simple black keyline border is effective and easily added to an image with Photoshop's Stroke tool. First select the canvas; the marching ants will appear where the border is to be applied.

Above: Photoshop's Actions menu contains a number of preset framing options, such as the Brushed Aluminium and Strokes effects shown here.

Adding a keyline

A good way to create an effective frame is to add a simple black keyline to an image; this can stop the viewer's eye falling off the end of a photo, but is subtle enough not to be consciously noticed. This isn't to say you can't be more adventurous, of course – just pick the right picture to be experimental with.

Adding a black keyline to your image is surprisingly simple. Just select the entire canvas by choosing Select > All or hitting Alt–A/⌘–A, then select Stroke from the Edit menu. Make sure the Inside option is ticked (this refers to where to put the lines in relation to the marching ants) and your chosen colour is selected. How wide a border you add will depend on the resolution and size of the image; start with a value of 5 pixels and work from there. You can always undo the effect and come back to the Stroke dialog box to change these options.

Frames Actions

Photoshop also has a number of built-in framing options that are recorded as Actions. Actions are a series of recorded steps that automate often-repeated tasks – we'll look at how to record your own Actions later in Chapter 6. To access the framing effects supplied with Photoshop, call up the Actions palette (Window > Actions) and choose Frames from the Palette menu (the small triangle in a circle).

To add a framing effect, choose it from the list and click the play button. Photoshop will cycle through the series of steps it has been pre-programmed – all you have to do is sit back and watch.

Digital manipulations

There is a difference between simple adjustments to brightness, colour and contrast and what many class as 'manipulation'. This often-used term seems to suggest a process that is more artificial – more high-tech and more digital. We all have our own ideas of where 'innocent' digital darkroom activity ends and hardcore manipulation begins. However, perhaps a useful distinction between the two is that manipulation creates an effect or image that is not what was actually recorded by the camera, and that is impossible – or certainly very difficult – to recreate in a traditional darkroom.

For instance, in Chapter 2 we learned about shade, tone, colour and contrast, while in Chapter 3 we will see how it is possible to correct for distortion and perspective effects without investing in a set of expensive lenses. We will learn how to create multi-layered images that allow us to depict part of a scene in black and white and part of it in colour. We will even learn how to photograph the impossible by compositing elements of several photographs together in to one image. Merging elements from a number of different pictures to form one composite image is a time-consuming but very enjoyable practice that can produce pictures that will have people coming back for a second glance. Equally impressive is the art of panoramic photography – that is, using Photoshop to stitch together several pictures taken in a row to produce a long, thin photograph. We will also discover how it is possible to go back in time, and restore a treasured old snapshot from a bygone age.

There is always argument about how much digital manipulation it is possible to get away with before photography turns into graphic design or illustration. However, some of the happiest and best photographers in the world let this debate rage around them while they get on with what is really important – taking photographs and creating great images.

Correcting slants

Even the best photographers need to straighten things up again every now and then. In an ideal world, we would all have spirit levels on our cameras and shift lenses to correct perspective, but then we would all be much slower and poorer. It's better instead to straighten things up afterwards during post-production on your computer.

Correcting sloping horizons

Many landscape pictures fail because the horizon is on a slant, a fault that looks especially odd if water is involved in the picture. A tried-and-tested way of correcting this in Photoshop is to:

1: Switch on the grid for reference
(View > Extras > Grid, or hit Ctrl–'/z–').

2: Select the entire canvas
(Select > All or use the shortcut Ctrl–A/z–A).

3: Use Photoshop's Free Transform tool (Edit > Free Transform or Ctrl–T/z–T) to rotate the picture. Hover the cursor just outside a corner of the selection and you will see it change to a Rotate tool. Hold the mouse button down and adjust the picture until it is level.

However, a much easier way is to find Photoshop's little-used Measure tool. Let's see how this works.

01 This is the original picture – a wonky grab shot, taken from a bus window.

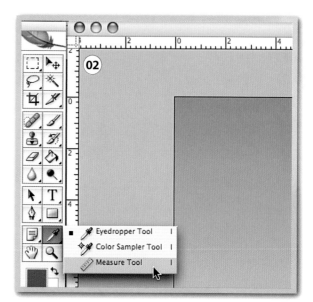

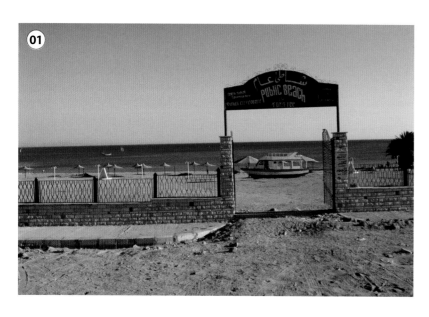

02 The Measure tool is in the same part of the toolbox as the Eyedropper tool. Select the Measure tool by holding the mouse button down on the Eyedropper to generate a pop-up menu.

03 Draw a straight line with the Measure tool along a part of the picture that is supposed to be either horizontal or vertical – in this case, the horizon. The longer this line is, the more accurate your correction.

04 Select Image > Rotate Canvas > Arbitrary. The number already entered in the resulting dialog box is the exact rotation needed to level the photograph.

05 The final image, with a straight horizon.

Focus on... correcting horizons in Raw

Sloping horizons are so common that Adobe have incorporated the facility to correct them into the Camera Raw plug-in, meaning this can be one of the earliest parts of the digital editing process. What's more, Camera Raw even crops the pictures for you, saving you a job in the main part of the application. Here's how it works.

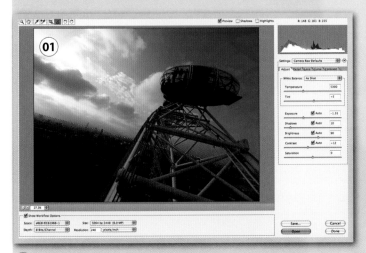

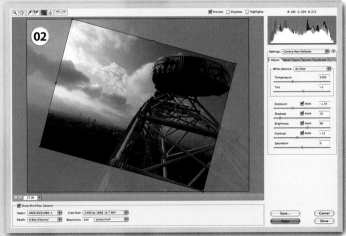

01 In Photoshop CS2 or Bridge, open the Raw file to be converted. Camera Raw will display it. Select the Straighten tool from the top left-hand corner of the dialog box and draw a line along the horizon in the picture.

02 Camera Raw adds a crop box at the angle needed to bring things back into proper alignment. After you have made any other adjustments that are required and hit Open or Save, the plug-in will straighten things up for you.

Correcting converging verticals

Converging verticals are the bane of an architectural photographer's life. They occur when the camera is looking up towards a structure and are particularly emphasized when using a wide-angle lens. There is nothing really unnatural about converging verticals – it is just perspective narrowing, the same as on flat land – but when buildings are seen through our eyes, our brain makes sure they don't appear as though they are leaning backwards or falling over. Unfortunately, no such correction happens on camera, unless a costly shift lens is used to alter the plane of focus when the shot is being composed.

Changing perspective

With digital photography, it is possible to change the perspective of a shot after the event, by effectively stretching one half of the picture more than the other. To do this, we will use Photoshop's Free Transform tool, which gives more versatility than the basic Perspective transformation tool.

01 Select the Canvas (Select > All or Alt-A/⌘-A) and switch to full-screen mode by hitting the F key. We'll need some space around the image to work with, so adjust the zoom level if needed.

02 Select Free Transform from the Edit menu and drag one of the upper corner handles outwards while holding down Ctrl+Alt+Shift/⌘+Alt+Shift). It is best to carry out these types of adjustments with the grid turned on, so you have a frame of reference of what is actually vertical. Do this by choosing View > Extras > Grid.

03 When the verticals are straight, the picture may look a little squat. An advantage of working with the Free Transform tool and not the Perspective tool is that this is easy to correct: release the Ctrl, Alt and Shift keys and drag the top or bottom handles until the image looks natural again. When you're happy with the result, hit Enter and Photoshop will make the adjustments permanent.

Focus on... Free Transform

Arguably the most useful of Photoshop's transformation tools, which are all tucked away in the Edit menu, is Free Transform. This has all the functionality of the other Transform tools rolled into one and can be applied without having to switch tools. For example, if a picture needs rotating, cropping, then skewing a bit, why carry out all these steps separately when they can be done in one go? The functionality of the Free Transform tool is dictated by which modifier key is held down.

PC SHORTCUT	MAC SHORTCUT	ACTION
-	-	Resize image by dragging a side or corner handle
Shift	Shift	Resize image while constraining proportions by dragging a side or corner handle
-	-	Rotate image by hovering pointer on the outside of a corner handle and dragging
Shift	Shift	Rotate image in 15° increments by hovering pointer on the outside of a corner handle and dragging
Ctrl	⌘	Distort the image freely by dragging a corner handle
Ctrl+Shift	z+Shift	Skew the image by dragging a side handle
Ctrl+Alt+Shift	z+Command+Shift	Apply Perspective correction to an image by dragging a side handle
Alt	Option	Apply the above distortions relative to the centre of the selection, not the top left

The Free Transform tool is great for making multiple adjustments to an image, for instance skewing, stretching and rotating.

BEFORE

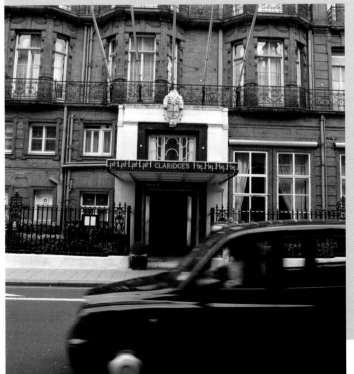

AFTER

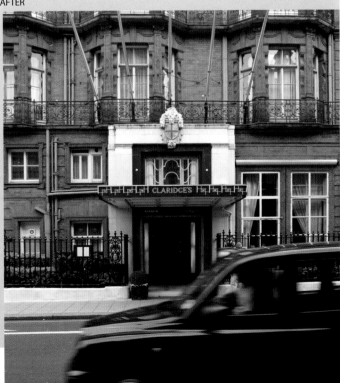

Correcting lens flaws

Photoshop CS2 features a Lens Correction filter. This superb tool is great for correcting the faults that plague the cheaper lenses built in to digital compacts and bundled with DSLR kits. Faults such as pincushion and barrel distortion, chromatic aberration and even vignetting can be fixed with a few clicks. What's more, settings for frequently used combinations of camera and lens can be saved for future use.

Dealing with distortion

The most common types of distortion are known by the nicknames 'barrel' and 'pincushion'. Barrel distortion, which is often exhibited by wide-angle lenses, is where straight lines near the edges of the frame appear to bend outwards. Pincushion is the opposite – lines near the edge of the frame bend inwards. This is often exhibited by telephoto lenses.

Barrel distortion is very common with digital compacts, as their small sensor size requires very short focal-length lenses. Compromises in the optical design of such lenses are also made in order to fit everything into a small body. Fortunately, fixing both barrel and pincushion distortion is easy with Photoshop.

Access the Lens Correction controls by selecting Filter > Distort > Lens Corrections. The Remove Distortion slider (1) has barrel distortion towards one end and pincushion at the other. To correct for barrel, slide the control to the right, keeping an eye on the image in the preview window (2). Having the grid showing is handy as a reference (3). Alternatively, select the Remove Distortion tool (4) at the top left of the screen and drag any part of the picture towards the centre to correct for barrel; drag it towards the edges to correct for pincushion.

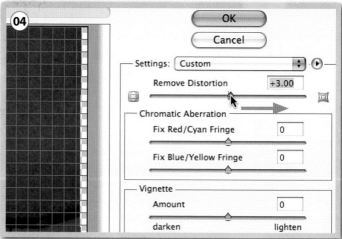

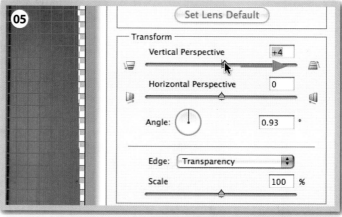

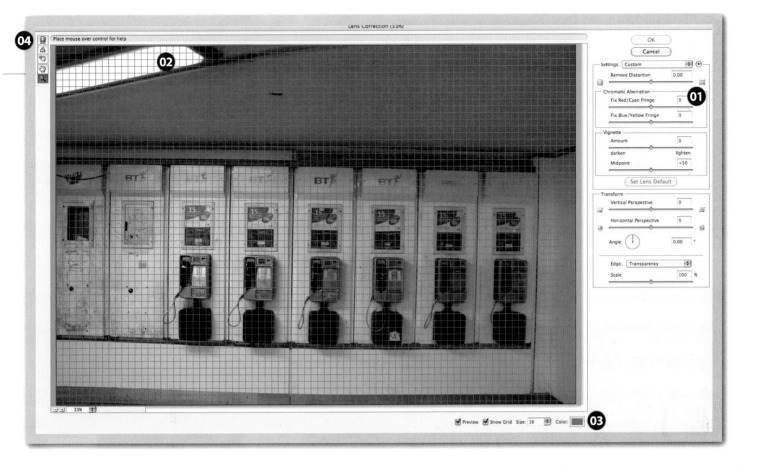

Barrel and pincushion distortion are especially noticeable in pictures that are taken straight on to a subject, and this is where the Lens Correction filter's other features can often come in handy. It is possible to correct the effects of the camera being uneven with the Straighten and Perspective controls. These have almost exactly the same effect as the Free Transform tool, which we looked at on the previous pages, but they work in different ways. In the end, which tool you use may come down to personal preference.

01 Let's see how the Lens Correction filter can sort out this grab shot. It needs levelling, and the budget wide-angle lens will have undoubtedly produced some barrel distortion that, if left unchecked, will spoil the parallel lines in the picture.

02 Select Filter > Distort > Lens Correction to begin the process. It is best to make the filter's window as large as possible and select Fit on Screen from the zoom menu in the bottom left corner.

03 Select the Straighten tool and draw a line along something that is supposed to be either vertical or horizontal. The Lens Correction filter will then straighten the whole image based on this.

04 Now the image is straight, it is possible to see the extent of the barrel distortion. Moving the Remove Distortion slider to the right quickly fixes this.

Adjust it slowly and make small movements – only a little correction is needed.

05 A little Vertical Perspective transformation is needed here to compensate for the camera being tipped downwards a little when the shot was being taken. Clicking OK tells the filter to make the changes on the actual image.

06 The adjusted image may have areas of transparency around the edges. If so, it will need cropping. Select the Crop tool and draw a rectangle that excludes any unwanted bits. In this image, a long thin crop has been chosen to suit the subject.

07 The final image.

Above: Some shots rely on straight, parallel lines to work. Photoshop's Lens Correction filter can help here.

01

Cloning and healing

Perhaps the most useful tool for a budding digital retoucher is the Clone tool. This can be found under a variety of names in many different software packages, but all versions do more or less the same thing: copy pixels from one part of a picture to another.

The potential for using the Clone tool to remove unwanted details from photographs is huge. That plastic bag that you overlooked in the middle of a landscape can be easily removed by copying some grass from elsewhere in the scene. And if the subject of a portrait develops a spot on the day of the shoot, then assure them it can be easily removed in post-production by cloning unblemished skin from somewhere else.

In Photoshop, the Clone tool is actually called the Clone Stamp tool. To use it, select which part of the image to sample pixels from by Alt-clicking it. Then choose a soft-edged brush that is about half the size of the detail being removed, and paint over it. It's possible to be fairly accurate with a mouse, but a

Above and right:
Removing unwanted detail is a job for Photoshop's Clone Stamp and Healing Brush.

05

graphics tablet gives a great deal more control and feel. The success of retouching with the Clone tool strongly relies on being able to find a suitable area of the picture to copy from. But what happens if the area being retouched and the area being sampled are of different brightness or different colours? To get around this problem, Adobe introduced a companion to the Clone Stamp tool in the form of the Healing Brush. This ingenious tool doesn't copy pixels exactly how they are, but rather copies texture, leaving shade, colour and transparency untouched.

For situations where there are many subtle shades of the same colour – retouching wrinkles in a portrait, for instance, or removing a bird from a cloudy sky – the Healing Brush is a great bonus.

With the Healing Brush also came the Patch tool. This works along the same principle, copying texture from one part of an image to another, but is designed for tackling large areas and is very quick to use. With the Patch tool selected in the toolbox, the area to be retouched is selected by drawing around it, in much the same way as a normal selection is made with the Marquee tool. The selection is then dragged to a part of the picture containing the texture to be sampled. The Clone Stamp tool, Healing Brush and Patch tool are complementary. For a good result, they are best used together as each is suited to a slightly different situation.

01 In this picture of an old boat, which was once used as a beach house in the Egyptian town of Dahab, I wanted to remove the parasols from either side to give a sense of isolation and space. This is a big job to tackle, but is a good example of what can be achieved.

02 The greater part of the wooden umbrella can be removed with the Clone tool. In this case, it is important to pick an area of the sky that is of a similar shade to the sky behind the parasol.

03 Being careful in selecting where pixels are sampled from really pays off. With a steady hand, it is possible to recreate a convincing replica of the line of the mountains on the horizon.

04 The devil is in the detail. Even after getting rid of all the obvious detail, the shadows from the parasols are still on the beach. Overlooking this type of thing can easily give the game away. Using the Healing Brush to copy beach texture from elsewhere, the shadows can be removed easily.

05 The final image.

Cloning and healing: coping with tricky situations

In most cases, cloning out unwanted detail from a photograph is pretty easy, but occasionally more complex situations arise. Photoshop's Cloning, Healing and Patch tools have their limitations, and a successful result for a digital photographer means knowing when these limitations have been reached and how to work around them.

For instance, although the Healing Brush is a powerful tool for digital retouching, it is not very good when put to work in regions where there is an abrupt change in brightness – along a high-contrast edge, for example. If you have ever tried using the Healing Brush on a detail next to an edge, you will probably have seen how it can cause a blurred smudge, which often looks worse than the artefact you are trying to get rid of.

A good way of getting around this is to draw a selection along the troublesome edge with the Lasso or Marquee tool, enclosing the area that is to be worked on so that only this is affected by the Healing Brush.

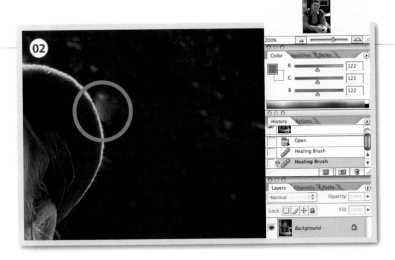

Let's see how this works using this quickly grabbed portrait as an example.

01 My first aim was to get rid of the distracting line in the brickwork behind the man's head.

02 Trying to get rid of the line with the Healing Brush leaves a light brown smudge by the edge of the subject's hat. The Healing Brush is getting confused, as it really needs an isolated area to work on.

03 Drawing a selection around the area to be healed will help to separate it from any interference from high-contrast edges. Don't get too close to the edge being protected, and, if you feather the selection, remember that this may bring in parts of the area being excluded.

04 When finished, the annoying line has gone, and the area next to our subject's hat is clean too. This technique can also be used with the Clone Stamp to speed up working around intricate edges, which are more easily picked out using tools such as the Magnetic Lasso (see pages 42–43).

Dealing with perspective

A long-standing problem for digital retouchers is cloning and healing in situations where there is perspective in a scene. There may be a suitable part of the picture to clone, but if it's at a different distance from the camera, the result won't look quite right.

Thankfully with Photoshop CS2 came the Vanishing Point tool, purposely made for such jobs – such as removing the shadow coming into the left on this picture, for instance.

01 The tool is activated by selecting Filter > Vanishing Point. It is best used full-screen, so the first thing to do is resize it.

02 Define the plane of perspective that you'll be working in by drawing this with the Create Plane tool, which you'll find in the toolbox to the left. Following an existing set of lines in the picture is a good way of practising this before you move onto more complicated cases.

03 Select the Clone Stamp and choose an area to clone from by Alt-clicking it (Option-clicking on the Mac). Paint over the objects being removed by clicking normally. The size and hardness of the brush are variable, just as they are when using the Clone Stamp normally. Turn the Clone Stamp into the Healing Brush by selecting On from the Healing menu.

04 When you're happy, click OK to render the finished picture. In this case, the shadow has been removed by painting over it with areas of tarmac from elsewhere in the picture. The Vanishing Point filter is especially good for preserving details such as the rails and paint lines on the road, where areas to sample from are limited.

BEFORE

AFTER

Retouching portraits

A major professional application of digital-imaging software is the post-production of studio photography. There are very few unretouched images in fashion and magazine-style portraits. No matter how beautiful models are, they rarely get away without some digital post-production being applied.

You too can give your portraits the makeover treatment with careful application of the various retouching tools in Photoshop. Experimentation and experience are the keys to success. Always work on a copy of the image in case you go too far; nobody wants to look like a mannequin!

Let's look at the digital post-production steps carried out after a magazine cover shoot with fashion model Fiona Brattle.

01 The 'before' shot.

02 Where the bright studio lights are shining on our model's cheek you can see the texture of her skin. We can smooth this out by passing the Healing Brush over it, sampling from darker skin that is in shadow.

03 These tiny skin blemishes can be easily removed with the Spot Healing Brush.

04 The stray hairs over the white background and the side of Fiona's head can be eliminated with the Spot Healing Brush and Clone Stamp tool, copying more background or straight hair where needed.

05 These lines under the eyes can be smoothed out with the Healing Brush. A small, soft-edged brush must be used to get between the eyelashes.

06 We can make the whites of the eyes even whiter with the Dodge tool, set to an exposure of 5 per cent so as not to overdo things.

07 Enhancing the blue in Fiona's eyes is done by first selecting them, with a combination of the Circular Marquee and Quick Mask tools, then applying a Hue/Saturation Correction to the selected portion. The Hue slider dictates the colour of her eyes; the Saturation slider controls how strong it will appear.

08 We cropped the stray edge of Fiona's dress from the bottom of the frame using the Crop tool.

09 The final image.

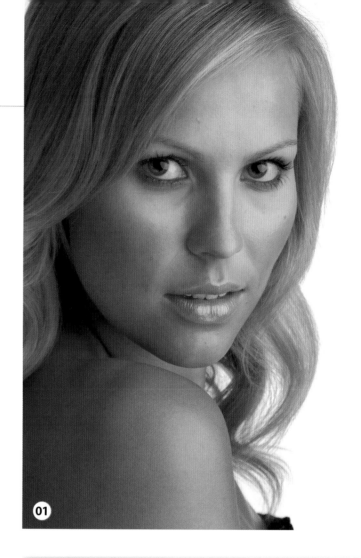

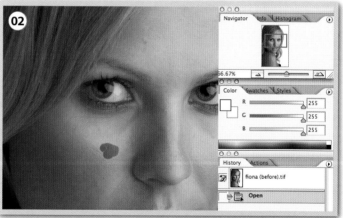

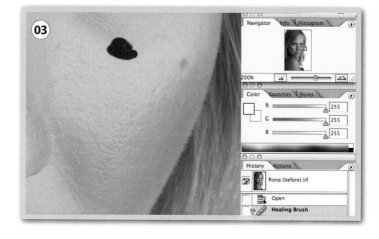

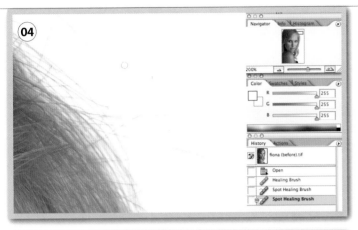

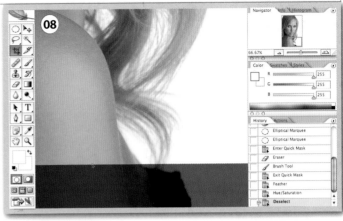

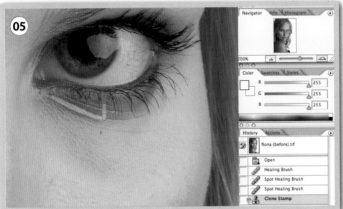

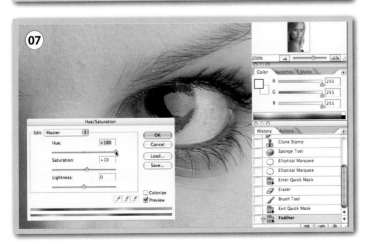

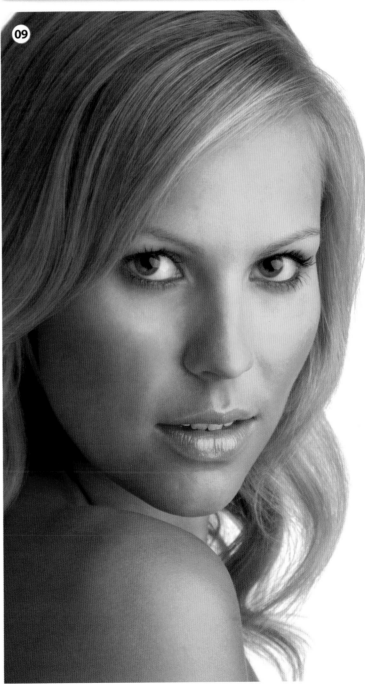

Restoration

We all have a box of photographs stuffed away somewhere. After all, one of the primary reasons for taking pictures is to capture memories of events or people important to us. Sadly, though, photographs don't last forever. Prints fade and suffer damage over the years, and photographic technology in the 1940s, for example, is not quite what it is today, meaning that picture quality can be less than perfect.

There is a case, then, for scanning these old prints and applying some 21st-century digital technology to them to preserve the image. It doesn't take very expensive equipment to do this – any entry-level flatbed scanner will be good enough to scan black and white prints, and with Photoshop, Photoshop Elements or similar software, you can restore the image to its former glory.

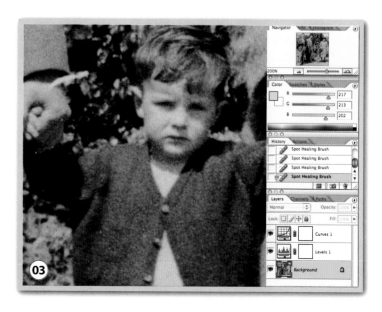

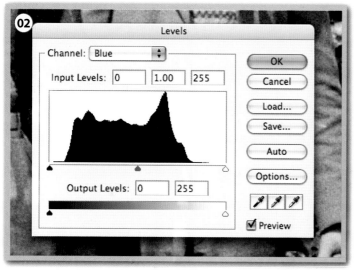

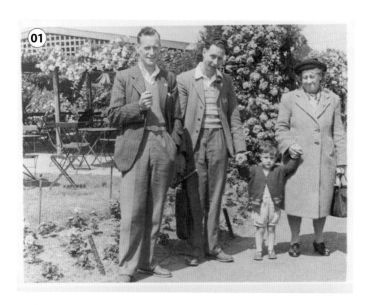

01 Let's look at an old print from 1948 that has become brown and faded over the years and see how it can be restored. This print has been scanned using an ordinary desktop flatbed scanner, set to colour mode in order to capture as much detail as possible. The bit depth should also be set to the maximum for your scanner (48-bit is not uncommon), as this governs the number of colours the scanner can see. The idea is to capture as much information as possible. It is a good idea to clean the scanner's glass thoroughly before starting; you'll be healing and cloning over any marks on the print, and there's no need to add to them with dust from your own office! If you can adjust the Levels of the image in your scanner's software, it's a good idea to do so at this stage. The better the image is straight from the scanner, the easier the rest of the process and the better the result.

02 Correcting for any fading that has happened over the years is a simple matter of making a Levels adjustment to add some of the missing contrast back in. Select Image > Adjustments > Levels and adjust the highlight and shadow markers so they meet the histogram at either end. While still in the Levels dialog, we can correct for any yellow colour cast that may be present. Using the colour cast correction method we encountered on pages 38–39, select the Blue channel from the dropdown Channel menu and move the midtone slider to the left to add some blue and reduce the amount of yellow.

03 Next, we'll work our way around the image, removing any dust, scratches and creases with the Spot Healing Brush, the Healing Brush and the

Clone tool. As we've seen, these three tools are complementary to each other, and each scanned print provides a unique situation, so it's hard to say where one tool scores over another. The more experienced you become at restoring old photographs, the more you will instinctively know which tool to use. And while you are learning you can always undo, so don't be afraid to experiment.

(04) When picking out dust marks and other artefacts to clone and heal, it's good to be methodical. Try working in a spiral, starting at the outside of the picture and working your way into the middle. This will ensure you cover every part of the print and don't miss anything.

(05) Lastly, crop and straighten the image and save an unsharpened copy to disk. When you print the image, you will want to sharpen it, using Photoshop's Unsharp Mask or Smart Sharpen filters. Afterwards, take a minute to look around the picture again at 100 per cent – the sharpening process may have made visible dust spots that you didn't see before, and it's worth taking these out with the Spot Healing Brush before you make the final print.

(04)

(05)

Left: The final image; a treasured family photograph rescued and restored for future generations to enjoy.

Working with layers

Working with layered images is something that many who are new to digital imaging avoid, perhaps because the concept can appear quite daunting. It is definitely worth persevering with, however: in Photoshop, working with layers unlocks some of the most powerful features of the software. In the pages to come we will come across many examples where using layers can give your images a real lift.

To understand how layers work, cast your mind back to the kind of painting and drawing you did as a child at school. Most of us have used translucent tracing paper in our time, or perhaps sheets of transparent overhead projector film. The way that these can overlap, so the images on them merge into one, is very similar to the way that layers in Photoshop work.

In Photoshop, however, there is a lot more control of exactly how the layers overlap – their transparency and how they interact with each other.

In a simple Photoshop document, the only layer that will be present is the Background layer. Look in the Layers palette (select Windows > Layers, if this is not already showing) and you will see this clearly identified as 'Background', with the name in italics and a small padlock symbol alongside to tell you that the positioning and properties of this layer are locked. New layers are always inserted above the Background layer, which must always be the bottom-most layer. The best way of converting the Background layer to a normal layer (something we will often need to do) is to double-click it and rename it – its status as the Background layer will then be automatically revoked.

We can see how this works by blending together two images (as two layers) of a wall and a red postbox.

Below and right:
The two original images of the wall and the postbox, ready to be blended together.

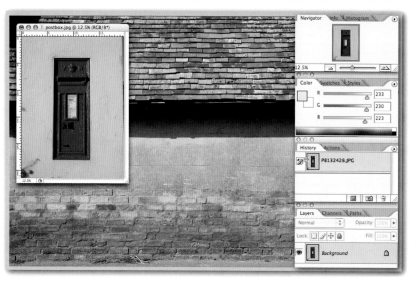

Left: Combining the two layers is as simple as clicking Alt+Ctrl and dragging from one window to another.

Adding, importing and sorting layers

To add a new layer, either select Layer > New Layer or click the New Layer shortcut in the Layers palette. You can rename a layer at any time by double-clicking it. Which layer is highlighted in the Layers palette determines which is active and therefore which is edited by your actions with Photoshop's tools.

Perhaps a more useful feature for a digital photographer is the ability to import layers from other Photoshop documents – after all, combining multiple images is one of the chief reasons for our interest in layers. The quickest way of doing this is to open both documents in Photoshop and drag an image-layer from one window to the other with the Alt and Ctrl keys held down (the Command and Option keys for Mac users).

Do this and you will notice the new layer placed on top of the original, and the appearance of a new layer in the Layers palette called 'Copy of background'. This is now a multi-layered document!

Moving our new layer about to align it is easy: click the Move Layer tool in the toolbox, or hold down the Alt key (Command for Mac users) and drag it. The arrow cursor keys can be used for very fine movements. Notice that with the top layer active in the Layers palette, anything we do by way of editing will happen to this layer only. For instance, take the Eraser tool and paint with a medium-sized brush over part of the upper layer. You should be able to see the Background layer through the hole you have just made in the top one. Erase more of the image and you will see how easy it is to combine photographs using layers.

Above: The final image: erasing parts of the uppermost layer with the eraser, the postbox and wall become part of the scene.

Blending modes and transparency

At the most basic level, layers in Photoshop sit one on top of the other and any transparency in the uppermost layer lets anything underneath show through. But that is not the only way in which layers in Photoshop can interact. Using the transparency slider in the Layers palette, it is possible to make an upper layer slightly see-through, so what is underneath can be seen.

Additionally, the way the pixels in an upper layer interact with those below it can be modified by changing the blending mode. This is done by picking a new preset from the dropdown menu in the Layers palette.

01

Focus on... blending modes

A detailed description of each of Photoshop's 23 blending modes can be found in the application's Help files (Help > Photoshop Help). Each does a different job, and may be more suited to some types of pictures than others, so it pays to play around and experiment.

Using the soft-focus technique explained here, changing the blurred layer's blending mode to Overlay boosts the colour saturation and contrast of the original image, and adds an ethereal diffuse glow too.

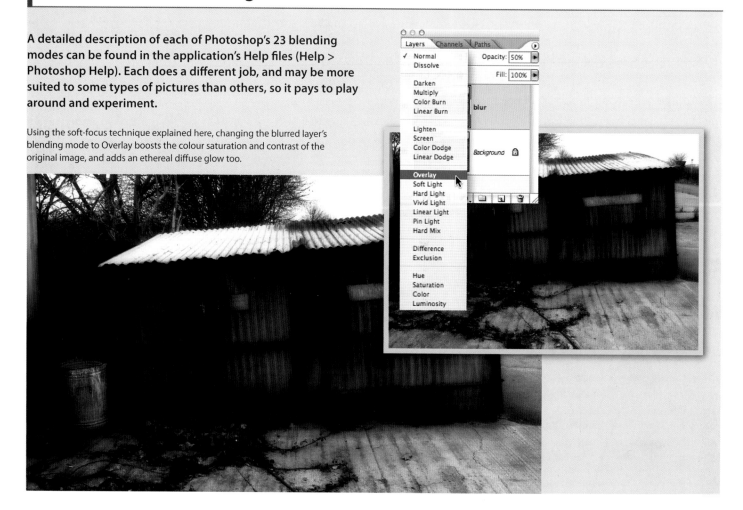

Soft-focus effects with layers

A good use for variable transparency and blending mode changes is to apply soft-focus effects to a photograph. The principle is simple: duplicate the layer containing the image so the Photoshop file contains two identical layers sitting one on top of the other. We can then blur the uppermost layer while at the same time reducing its opacity to let the sharp version shine through slightly.

01 The 'before' image.

02 Duplicate the background layer by right-clicking

it and selecting Duplicate from the pop-up menu. Name the new layer 'Blur'.

03 Blur the top layer using the Gaussian Blur filter located in the Filters > Blur menu. A Radius of around 20 pixels is about right.

04 Make the blurred layer slightly see-through by sliding the Opacity control to the left until the effect looks good. A value of 40 to 50 per cent should do well.

05 The finished image.

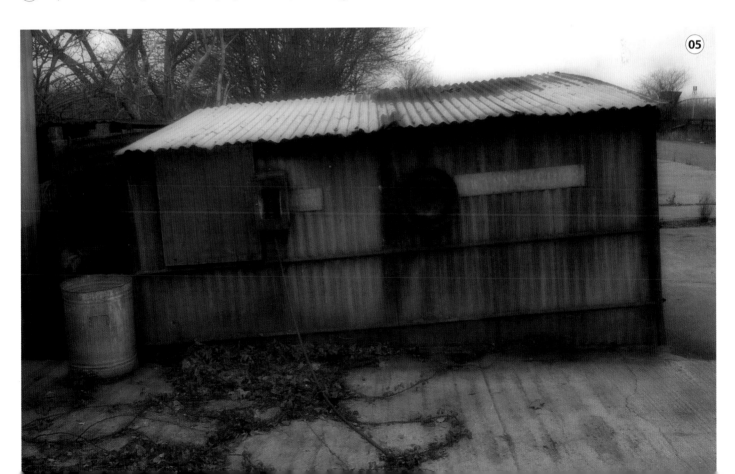

Selective colouring

A great effect that is easy to create with layers is selective colouring of a black and white photograph. Picking a picture that suits this effect can be tricky, as the scene ideally should work well in black and white by itself, but also have a strong burst of colour that will look good as the focal point of the picture. But once you have found a suitable image, the effect takes only a few minutes to apply.

Layer masks

We will use a layer mask to apply the selective colouring effect. A layer mask is a way of specifying which parts of a layer should be visible, and which shouldn't, by drawing and editing with Photoshop's normal range of tools. The way the layer masks work is very similar to the Quick Mask (see pages 44–45), with the difference that there can be different layer masks for every layer in an image, and they can all be edited, copied and deleted at will.

01 The 'before' picture.

02 When you have decided on a picture, open it in Photoshop and duplicate the Background layer by right-clicking in the Layers palette and selecting Duplicate Layer. Call the new layer something distinctive, such as 'Mono'.

03 With the Mono layer active, select Image > Adjustments > Desaturate to make it black and white. The whole picture should now be in greyscale, as the Mono layer is on top, obscuring the colour version lying beneath.

04 To create a new layer mask, click the shortcut button in the Layers palette – the layer mask is shown as a new rectangle alongside the layer it is assigned to. Click on the layer mask rectangle and any edits

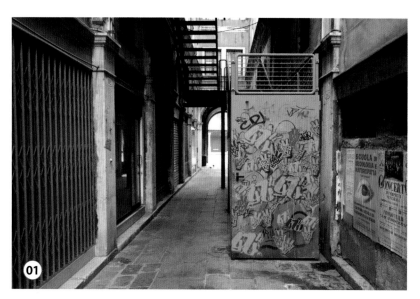

01

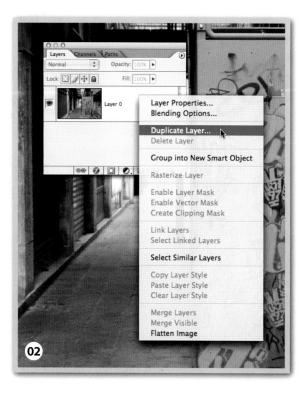

02

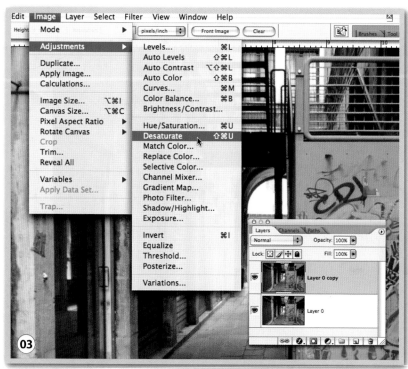

03

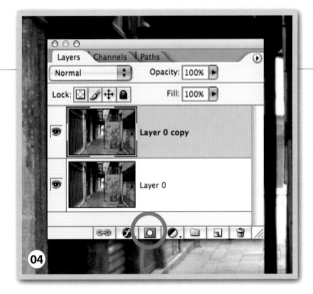

you make will apply to the mask; click on the image rectangle, and the edits will apply to the image itself.

05 With the layer mask for the Mono layer active, select the Paintbrush from the toolbox and pick black as the foreground colour. Paint over the object you wish to make colour again using a small, medium-soft brush. To delete some mask (if you go too far, for instance), select white as a foreground colour and paint it out.

06 When you are finished, the layer mask can be copied to other layers by dragging in the Layers palette. This is also useful for other effects, such as colour boosting with the Hue/Saturation controls.

07 The final image.

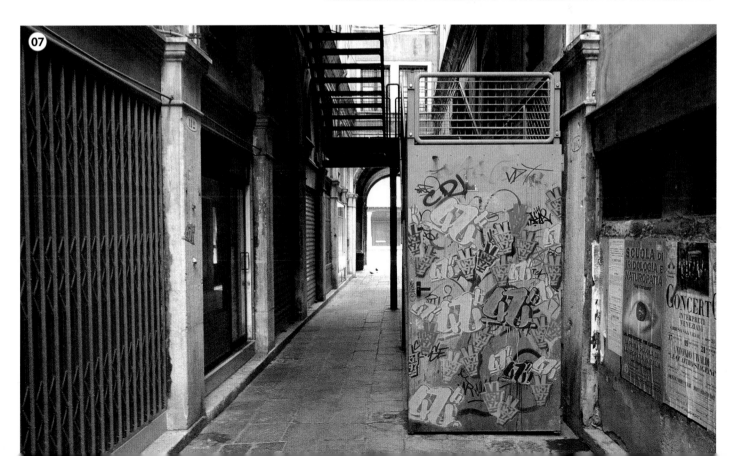

Compositing and montages

It is often said that the only limit in digital photography is the photographer's imagination. This is never truer than when compositing is concerned. Compositing is the practice of combining elements from many different photographs to form one (fictional) image – which can look fairly realistic or completely out of this world. The simplest example of a composite image might be to take a picture of the moon and drop this into a night-time landscape. Or it may be as complex as taking many shots of a room with just one person in it before blending these together to form a fictional party, attended by a crowd of clones. Either way, compositing in Photoshop makes extensive use of layers, as we'll see in this example.

Making a composite image

(01) This picture comprises fifteen individual frames, all shot from the same position over about ten minutes whenever a white van entered the frame. We'll start with a background of an empty road and add white vans by importing them as separate layers from the other images.

(02) This is the background image, with which we'll start. It is not quite an empty road, but at least the only vehicles in it are white vans, which should save some time.

(03) Adding a white van involves opening another image, selecting the van roughly with a Lasso tool, and

dragging the selection into the background image with the Ctrl and Alt keys held down (Option and Command on a Mac). This will import the van as a new layer.

04 Tidying up the rough selection involves using the Eraser tool to delete anything surrounding the van. A steady hand is required, and you might find working with a graphics tablet easier than using a mouse.

05 Don't be afraid to zoom in to look at what you are doing at a high magnification of 200 to 400 per cent. Use a small, medium-soft brush near the edges and take your time, occasionally zooming out to see what the image looks like as a whole.

06 Repeat this procedure – select and drag a van to import it as a new layer, then tidy up the selection with the Eraser tool – until all the items to be composited are in the same frame.

07 At this point, you will have a lot of layers showing in the Layers palette. To continue, it is best to flatten the image into one layer. Before you do this, save a copy of the layered version so you can come back to it if anything goes wrong.

08 This is now an ordinary single-layer Photoshop document like any other we have encountered in this book, and as such any of the application's editing tools can be used on it. Here, we tweaked the Levels a little and adjusted the colour saturation.

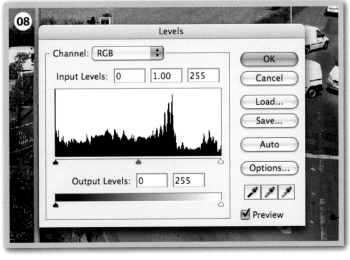

01

Digital panoramic photography

The appeal of the panoramic picture format has been known to landscape photographers for decades. Thanks to digital photography, this long, thin aspect ratio has seen a resurgence in popularity, and is now found in the portfolios of architectural, interior and fine-art photographers too.

The easiest way to create a panoramic photograph is to crop the top and bottom off a normal-shaped image; in fact, this is how the panoramic option in APS film cameras used to work. This does not increase a camera's angle of view, but it can help with composition when foreground interest is lacking in a landscape, or a tight crop is wanted. This effect is easy to achieve in Photoshop or any other digital-imaging application with the Crop tool, and the availability of panoramic-sized inkjet paper means your letterbox-sized images can be output at home too.

The cropping method has a couple of disadvantages, however. As mentioned above, simply lopping off the top and bottom of the picture doesn't add any width to the sides. You are throwing away half of the picture area, and, as a great deal of magnification

is required to get good-sized prints, this can lead to a significant drop in image quality. So what's the solution?

Stitching pictures together

The concept of stitching is a simple one. Instead of using a wide-angle lens to shoot a panoramic subject, choose a short telephoto and take a series of pictures working your way from left to right across the scene, making sure each frame overlaps the previous one by about a third. Photoshop – or a similar application – can then overlap the individual frames, 'stitching' them together. Sounds easy? Well, yes, it is.

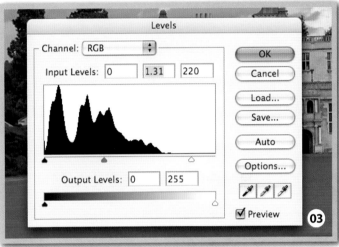

01 These pictures of Audley End stately home in Essex, England were taken from a distance using a 200mm lens (35mm equivalent). To overlap and merge them in Photoshop or Photoshop Elements, choose File > Automate > Photomerge to open the Photomerge stitching module. Click Browse for files and select the component images.

02 By default, Photomerge attempts to overlap the component pictures automatically, but if it struggles then you may have to arrange them yourself. Simply drag the individual thumbnail images from the top of the box into the main window and arrange them as best you can. Click OK to proceed.

03 When Photomerge has done its work, the stitched picture is opened in Photoshop for you to look at. This is now a normal digital image like any other, and as such can be edited with all of Photoshop's tools. Go round and make sure there are no stitching artefacts, such as ghosted images or gaps, and apply any tonal corrections. In this case, we have tweaked the final image's levels, and cropped it slightly.

04 The finished panorama.

Remembering common sizes

If you want to reproduce the aspect ratios shot on film by panoramic photographers, why not define them as preset crop sizes so they are available at the click of a mouse? Enter the size you want in the width and height boxes at the top of the screen (for instance, 65x24mm for Hasselblad's famous XPan format, or 17x6cm for the medium-format aspect favoured by landscapers such as Colin Prior and Tom Mackie) and click the New Preset icon. Leave the resolution box empty to avoid interpolating the image.

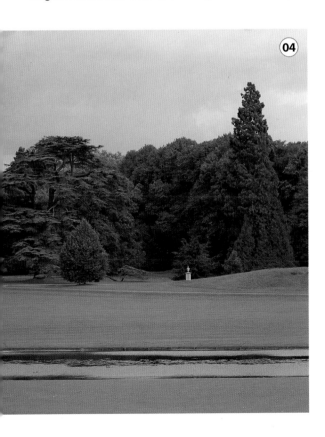

Extreme panoramic

Digital photography has let photographers capture panoramic pictures without having to use specialized equipment, but that's not all. Thanks to digital stitching, it is now possible to shoot a complete, 360-degree panoramic showing absolutely everything in a scene for a truly spectacular result. The technique works best with a wide-angle lens and with the camera mounted on a tripod. If the scene contains both near and far objects then the best results will be obtained by using a so-called panoramic tripod head. This ensures that the camera is revolving around its lens's nodal plane – the place inside the optics where the light paths cross before hitting the digital sensor. This avoids parallax error as the camera is rotated. If you are shooting with a compact you may be able to get away with a normal tripod head, as the distances involved are much smaller.

In 360-degree panoramic photos, expect horizontal lines to bend and distort as they get nearer to the camera. Parallel lines, such as train tracks, look bizarre when they are either side of the camera.

To cover a full circle with a normal 28mm wide-angle lens requires 12 images to ensure good overlap between neighbouring frames. To get these to stitch together properly we need a more powerful software solution than the Photomerge facility in Photoshop. Several options are available, of which Realviz Stitcher is a good example. This powerful package warps the component images so they overlap with each other perfectly. It also takes into account the distortion produced by very wide-angle lenses, so it is even possible to cover a complete circle with only three shots when using a fisheye lens.

Panoramic stitching software

There are a few options available now in this growing field. Most software manufacturers have trial versions available for download from their websites that let photographers try stitching for themselves before they make the plunge and buy an application.

- Realviz Stitcher: available from www.realviz.com
- Apple QuickTime Authoring Studio: available from www.apple.com
- Panoweaver: available from www.easypano.com
- PanaVue: available from www.panavue.com
- 360 Panorama Professional: available from www.360dof.com

01 The individual frames to be merged together to create the panorama.

02 The first step is to import the pictures into Realviz Stitcher and assemble them in the correct order by dragging them into place.

03 Once each frame is positioned roughly the software stitches it, calculating the precise amount by which each component image must be warped to match its neighbours.

04 When all individual images have been stitched together, the software renders the final picture and outputs it as a TIFF or JPEG file, or even as a virtual-reality QuickTime movie.

05 The completed panorama.

Focus on... shooting panoramas

Here are a few tips to help you when shooting panoramas.

• Make sure everything is level. If your camera is pointing up or down as it is rotated, the software may have trouble stitching the frames together, and you will end up with a wonky horizon, too.

• Shoot in manual exposure mode and with a manual white balance setting. Changes between frames can show in the final image.

• Position the camera on its side to make the most of the sensor's longest dimension.

• Use a tripod. You may be able to get away with handholding when shooting a few frames at a distance, but precision work requires you to keep the camera in exactly the same place.

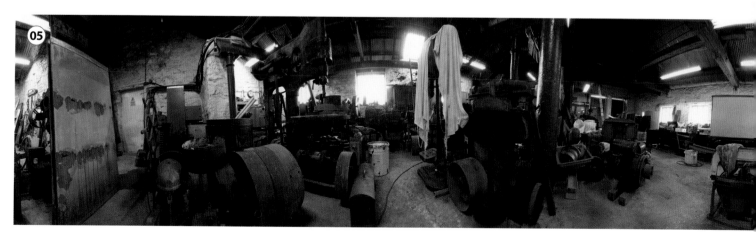

Digital black and white

Black and white photography has survived a lot over the many years since its invention. After all, this is where photography started out back in the nineteenth century, and with the invention of colour film in the 1930s, who could have thought that 75 years later we would still be shooting in monochrome? So what is it about black and white photography that makes it so magical? Ask anyone in the street and you will hear words such as 'moody' and 'atmospheric'. Taking this a step further, maybe the reason that black and white is so popular is that, without the distraction of colour, we are free to focus on what gives a scene its character or atmosphere. After all, colour is a luxury in photography. What gives feeling to a picture is tone and contrast; shapes and lines; pattern and texture.

In many ways, shooting in black and white brings photography back to basics. Portrait photographers, who appreciate the timelessness a monochrome portrait can have, are thankful for the honesty of black and white, while landscapers revel in its ability to capture perfectly the atmosphere of a location.

Black and white photography continues to thrive in the digital era. Many digital cameras have black and white modes, and while these are best avoided for the best quality monochrome pictures (it is best to shoot in quality and convert them to monochrome afterwards, as we'll see), this does give a photographer a preview of what a scene will look like in monochrome.

In this chapter, we will explore some of the myriad ways of taking a colour picture and converting this to black and white using image-editing software. Some are easy, one-click methods, while others are more complex, but offer extra sophistication and flexibility. We will also look at how some of the classic wet-chemical black and white printing techniques, such as toning or dodging and burning, can be recreated in your digital darkroom without the time-consuming and costly mess that used to be associated with making black and white prints at home.

It seems that monochrome will be a medium that photographers (even digital ones) will continue to work in for many years to come.

Converting to black and white

Wherever photographers gather, it's possible to overhear conversations about converting images from colour to black and white. Everyone, it seems, has his or her own way of tackling what should be a relatively easy task. After all, it's just about removing the colour, isn't it?

Well, yes and no. It's not just about removing the colour. It's also about making sure that the grey tones that result are the right grey tones. Traditionally, film photographers control the tones in their black and white pictures with coloured filters that selectively darken some colours while lightening others, and by using different developers and printing papers. Of course, digital photographers can use filters too, but it's also possible to take control of much of this fine-tuning in computer, after the shot has been taken.

Simple, one-click black and white

Let's start with some easy-fix ways of creating a monochrome image in Photoshop. For many, the first way of removing all colour from a photograph is simply to switch modes, from RGB colour to Grayscale. You will find this option tucked away under Image > Mode. Alternatively, selecting Image > Adjustments > Desaturate removes the colour while remaining in RGB mode; this is handy if you wish to go on and tint the image with a drop of sepia-like yellow, for instance.

If you have never compared these two methods, you could be forgiven for thinking that they produce the same result, but they don't. Examine the two pictures left and you will see that the image produced by switching to Grayscale mode is more punchy and has more contrast than the photograph that has been desaturated. That said, the desaturated picture retains a little more detail in the brighter parts of the picture (the highlights).

It's not that either one of these methods is better than the other, more that comparing them teaches us an invaluable lesson: it is important to understand many ways of converting an image to mono and know which particular image will suit which technique. Never be afraid to experiment – you can always go back to the beginning and start again.

Top to bottom: The chimneys of Gaudi's Casa Mila in Barcelona in colour; after conversion to Grayscale mode (middle); and after desaturation in RGB mode (bottom).

Focus on... blending modes and black and white

If, like many others, you find black and white pictures produced by these two basic methods convenient, but a bit lacking in punch, there's an equally quick way of injecting a bit more life into them using Photoshop's extensive range of blending modes.

In the Layers palette (Window > Layers, if it's not already showing), duplicate the layer containing your monochrome image by right-clicking it and selecting Duplicate from the resulting pop-up menu or choosing Layer > Duplicate layer. Now change the blending mode of this layer by selecting an alternative from the palette's blending-mode menu.

It is worth playing around with various options, but Screen blending mode is good for images that could do with being lighter, while Multiply or Overlay are good ways of darkening things down somewhat. If the outcome of the new blending mode is too great, slide the opacity slider to the left to decrease the effect.

These images demonstrate the effect of (clockwise from top left) Normal; Screen; Color Dodge and Hard Light blending modes.

Right (top to bottom): The red, green and blue channels shown separately.

Below: The colour version.

Below right: The Channel Mixer gives you control over the monochrome effect of an image.

Channels and monochrome

You may have worked out by now that digital photographs are made up of three distinct colours – red, green and blue – that, when mixed together in the right proportions, can give rise to almost every colour imaginable. If you were able to look closely at the sensor in your digital camera, you would see that it consists of three types of sensors: one set to record red light, another to record green light, and a third to record blue.

When a digital picture is taken, the data from each set of sensors is stored as a channel and mixed together afterwards to give the picture we are used to seeing on our camera's viewscreens or computer monitors. But these groups of sensors can see only brightness; individually, they know nothing about colour. This means that each channel is actually a monochrome picture, just waiting to be exploited by a black and white photographer.

The three channels

If you want to see what each channel looks like on its own, look in the Channels palette (Window > Channels, if it's not already showing). Assuming you are in RGB colour mode (we'll look at some other modes later), the Channels palette shows each channel in much the same way as the Layers palette shows layers, as well as the result of mixing all three channels together to form a colour image. To see what a channel looks like on its own, just click it. The image should instantly update to show the effect.

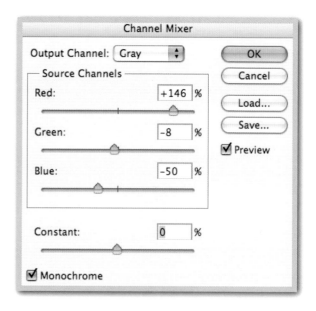

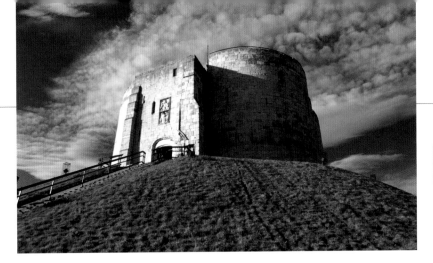

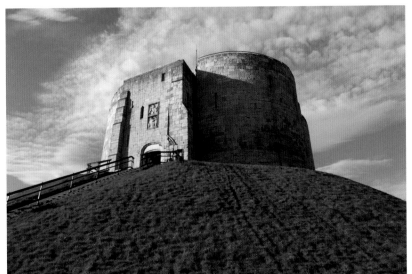

Focus on... Lab Mode

Taking a single channel and turning it into a monochrome image isn't only possible in RGB Color mode. Try switching to Lab Color mode (Image > Mode > Lab Color) and giving it a go.

Lab mode uses three channels to describe an image, just like RGB mode does. The only difference is that Lab's channels contain information on just two colours, and the image's brightness. Its uses are fairly limited in digital photography, but taking just the lightness channel does give a good monochrome image, and is always worth looking at as an alternative to a single channel from RGB mode.

Above and top: This black and white image was produced by simply converting the image mode to Grayscale.

To turn one of these channels into a monochrome image that can be saved, printed and worked on, make sure the correct channel is selected and then choose Image > Mode > Grayscale to dump the information from the other two channels.

In this example, the three monochrome images have very different looks – when transformed to grey tones, certain colours appear lighter in one channel than another. To be more scientific about this, reds appear lighter in the red channel, greens are lighter in the green channel, and blues are lighter in the blue channel. Which channel gives the best result is decided by the colours in the picture being converted (a scene with masses of blue sky often looks good viewed only through the red channel, for instance). If none of the channels looks quite right, it may be time to progress to the next level and mix multiple channels together.

The Channel Mixer

Photoshop's Channel Mixer behaves exactly as its name implies. It mixes red, green and blue channels together but in amounts specified by the photographer. It can be found by choosing Image > Adjustments > Channel Mixer.

First, tick the Monochrome box to make sure the result of mixing all three channels together is greyscale and not colour. By default, the red slider is set to 100

per cent, which can be a good place to start. The idea here is to selectively darken or lighten objects of a certain colour by adjusting that colour's channel slider, then use the other sliders to maintain the overall percentage as near as possible to 100. For example, to darken the shade of grey produced by a blue sky, drag the blue slider to the left and compensate for the drop in brightness by moving the red and green sliders to higher values. The Constant slider can be used for changing overall brightness without tweaking the individual channels, though use this with caution as it can result in an overall drop in contrast.

Put a different way, converting to monochrome with the Red channel set at 100 per cent is like photographing a scene through a red filter – blues and greens will be darker. Likewise, a blue filter can be simulated by a 100 per cent blue channel, and a green filter by a 100 per cent green channel.

The plug-in way

With all of this talk of channels, curves and blending modes, you may be forgiven for thinking that getting black and white right is hard work. It can be, but there are some third-party plug-ins available to make the task easier for aspiring mono workers.

Plug-ins are a great way for software developers to add extra functionality to Adobe's Photoshop and Photoshop Elements and Corel's Paint Shop Pro. Install them by dropping the relevant file into the Plug-ins folder on your hard disk and the new functionality will magically appear in Photoshop's Filters menu. Some of these plug-ins are free, while others are available to try for a limited period and then require a small fee to activate them permanently.

Two of the best black and white plug-ins available are Convert to B/W from the Imaging Factory (www.imagingfactory.com), and BW Workflow Pro from Fred Miranda (www.fredmiranda.com).

Convert to B/W

Despite its widespread popularity, the Imaging Factory have not rested on their laurels with Convert to B/W; they have constantly updated it, even adding a Pro version that has added functionality. The big bonus with Convert to B/W is that the controls are labelled in terms that anyone who has ever worked in a traditional darkroom will understand instantly. Contrast is referred to in terms of multigrade paper, while sliders for negative exposure and printing exposure are also available. It possible to mimic the effect of coloured filters in front of the lens, and even simulate the colour response of some popular black and white films, such as Ilford FP4 and Kodak T-Max.

BW Workflow Pro

Fred Miranda is responsible for many fantastic digital-imaging plug-ins, so his pedigree here is a good one. BW Workflow Pro works in a slightly different way from Convert to B/W, as it resides in Photoshop's Automate menu (which you will find tucked away inside the File menu). In line with this change in location, one of BW Workflow's strengths is its ability to batch-convert a series of files from colour to monochrome using its own scripting engine.

There is plenty of scope for experimentation with this plug-in, with 8 colour filters, 32 duotone presets, 18 tritone presets, 6 quadtone presets and 4 dynamic range presets to help recover lost shadow and highlight detail. It also allows you to add realistic-looking film grain, which many black and white film workers will appreciate.

Right: Options galore in BW Workflow Pro (www.fredmiranda.com).

Below: The photographer-friendly interface of Convert to B/W (www.imagingfactory.com).

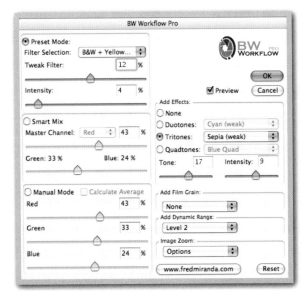

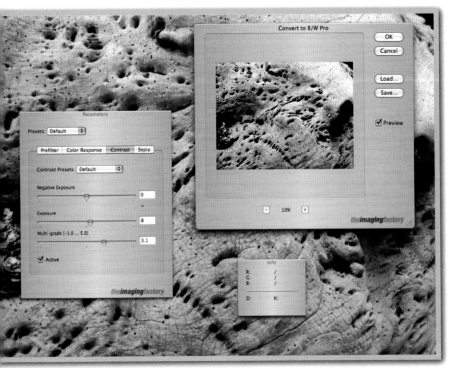

Right: A black and white conversion plug-in is a simple way to get punchy, monochrome pictures.

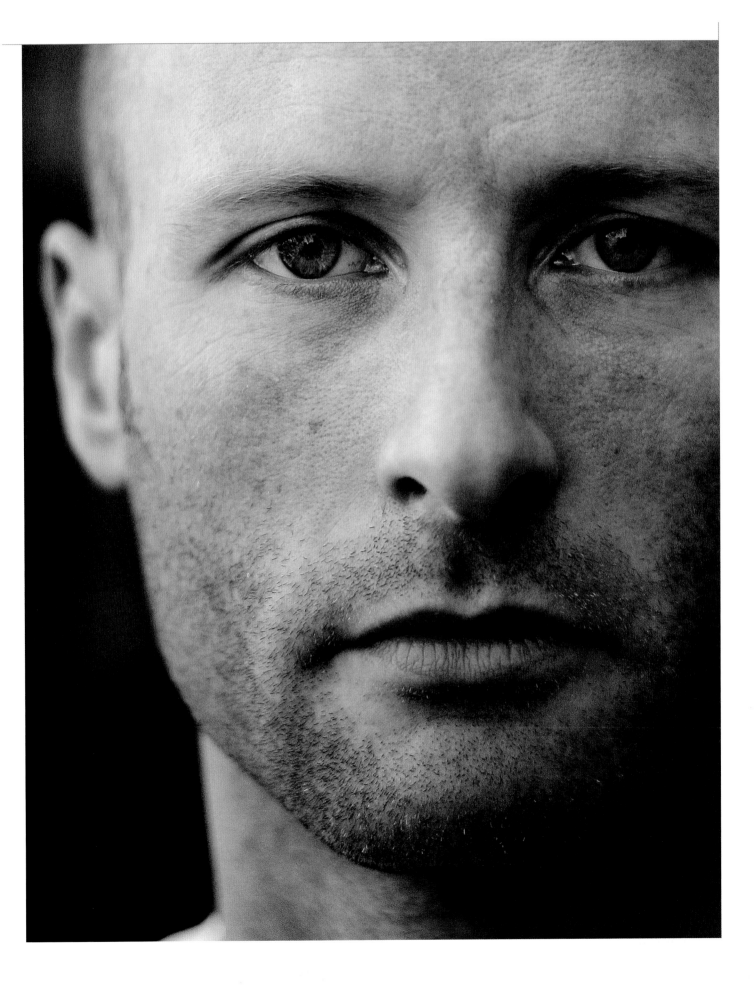

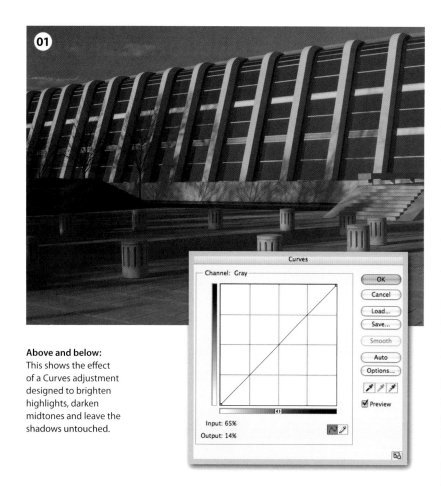

Above and below:
This shows the effect of a Curves adjustment designed to brighten highlights, darken midtones and leave the shadows untouched.

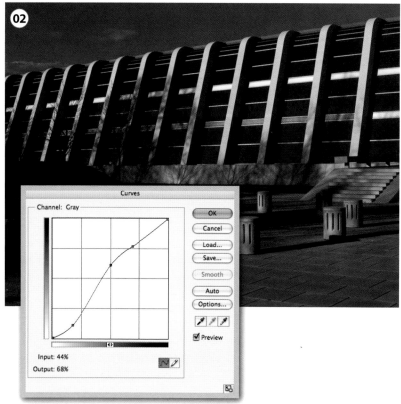

Controlling contrast and tone

Traditional darkroom workers have great control over the contrast and brightness levels in a black and white picture. Some subjects need careful, gentle treatment with soft contrast and high-key brightness, while others cry out for punchy blacks and milky whites, with few shade of grey in between. Of course, the digital worker has this control too.

A Levels adjustment dialog box presents us with three points: black, white and mid-grey, which we can use to control the brightness in a picture. By moving these pointers we are redefining where black, white or mid-grey come in relation to the other brightness levels in the picture. But what happens if another shade of grey needs redefining? This is where Curves come in. The best way to understand a Curves adjustment is to have a look at one.

01 Open an image into Photoshop and select Image > Adjustments > Curves. Look along the bottom of the graph. The range of greys represents the brightness levels in the picture before any adjustment has been carried out. Imagine a line coming up from a specific shade, hitting the straight line and then moving out left to the other greyscale range. The shade that it hits will be the effect of applying the Curves adjustment. When the line is straight like this, the initial grey will be the same as the final grey – in other words, there is no effect. To cause a change, we must change the shape of the curve.

02 Click once in the middle of the straight line to create a point and drag this vertically upwards. This will have the effect of darkening the midtones of the image while leaving the highlights and shadows unaffected. Let's lighten the highlights by creating a point near the bottom left end of the line and dragging this downwards. This will have the effect of moving the top right of the line upwards, so you might want to compensate for this by creating another point there and forcing it straight again. Once again, imagine a straight line from the greyscale at the bottom of the graph up to the line and left over to the greyscale for the results. Now you can see that the result for mid-greys is darker than it was originally, while highlights are lighter than they were.

This is just one way of using Curves, which brightens highlights, darkens midtones and leaves shadows untouched, but there are many more combinations.

Getting started with Curves

Here are some common curve shapes, and their effects, to get you going.

01 Brightening midtones only

02 Reducing contrast with an inverted S-shaped curve

03 Increasing contrast with an S-shaped curve

04 Lightening shadows only

05 Darkening highlights only

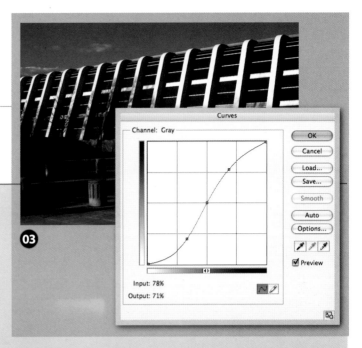

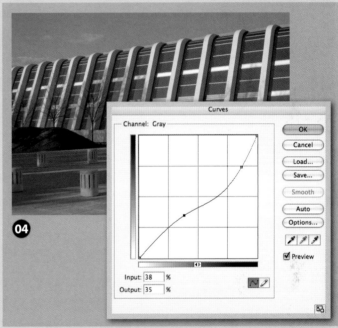

03

Input: 78%
Output: 71%

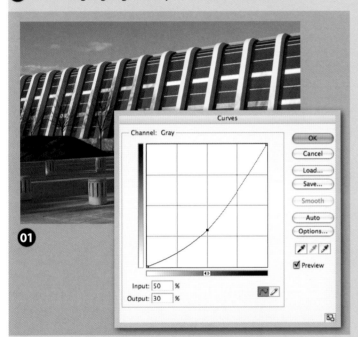

01

Input: 50 %
Output: 30 %

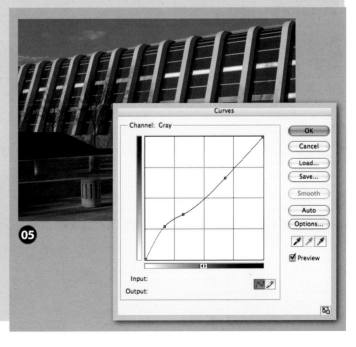

04

Input: 38 %
Output: 35 %

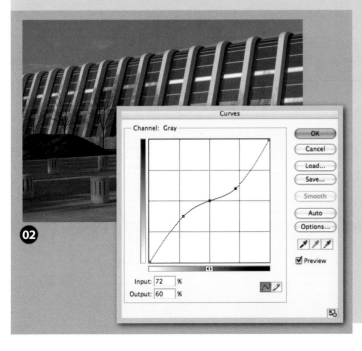

02

Input: 72 %
Output: 60 %

05

Input:
Output:

Grain, not noise

For years, film manufacturers strived to provide finer and finer grain films. There are occasions, however, when a really grainy look suits a subject, and certain films, especially black and white films, have long been exploited and loved for this quality. Documentary photography, or any subject that warrants a hard, gritty treatment, particularly benefits from a grainy approach.

The digital equivalent of grain is noise, and unfortunately this is not as aesthetically appealing. Noise arises when a digital camera's ISO rating is set to high values. It is more splodgy and not as randomly distributed as film grain. If you want a grainy effect when shooting digitally, you are better off minimizing the noise producing in camera, and introducing some artificial grain afterwards using Photoshop's Noise filter.

The Noise filter should really be called the Grain filter, because the effect it gives is much more like the grain in a film emulsion than the noise on a digital chip. The filter can be found under Filters > Noise > Add Noise, and is very simple to use. The preview window shows a simulation of the effect about to be applied by the Amount slider. An Amount of about 5 per cent is usually enough for printing on paper; you may need a lower Amount for low-resolution screen images. The effect sometimes looks less marked on screen than it does on

paper, so don't be tricked into overdoing it. If in doubt, make a test print or view the photo at 100 per cent view.

The other two controls are worth mentioning too, as they can significantly change the look of the noise the filter generates. Setting the distribution to Uniform produces smooth-looking grain, whereas Gaussian gives a more speckled effect. Ticking the Monochromatic box is a good option – especially with a black and white image – as this limits the noise to the brightness of the picture only, not the colours.

Once the grain has been applied, it can be made a little more film-like by applying a very small Gaussian Blur to the image (Filter > Blur > Gaussian Blur). A value of about 0.2 to 0.4 should be effective.

Above right: The Gaussian Blur filter.

Right: The easy-to-use Add Noise filter in action.

Left: The original picture converted to black and white.

Left: The image with the subtle 'film grain' added courtesy of the Add Noise filter.

Tinting and toning in Photoshop

Monochrome images don't have to be just black and white. For years, traditional monochrome workers have been adding subtle colour effects to their prints in the darkroom. They could produce sepia-style brown and white pictures, or bluish selenium-toned images by treating their prints with different chemicals. Photoshop users can achieve the same toning effects digitally, with more control and a greater range of colour options.

Applying a simple coloured tone

A simple way of applying a colour tone, such as sepia, to a black and white picture is to use a solid colour layer, and change the blending mode so that the colour affects only the darker greys in the picture.

01 After converting the picture to black and white in whichever way you wish to, make sure the image is contained in a single layer – flatten multiple layers into one by selecting Layers > Flatten image if you need to.

02 Next, insert a new fill layer by selecting Layer > New Fill Layer > Solid Colour. The colour you choose here will determine the type of tone applied to the picture. A good starting point for a sepia tone is Red: 225, Green: 185, Blue: 40. Apply the solid colour to your picture by changing the blending mode from Normal to Color Burn. You can dilute the effect by decreasing the Solid Layer's opacity.

03 A great deal of control can be exerted over the toning given to an image through the Blending Options dialog (Layer > Layer Style > Blending Options). By moving the white-point slider to the left, it is possible to determine at which point the image becomes too light to tone. Simply moving the marker produces a rather abrupt transition, though, so it's best to split it in two by Alt-clicking it and marking out a range over which the transition from 100 per cent to 0 per cent toned will occur.

04 The finished toned picture.

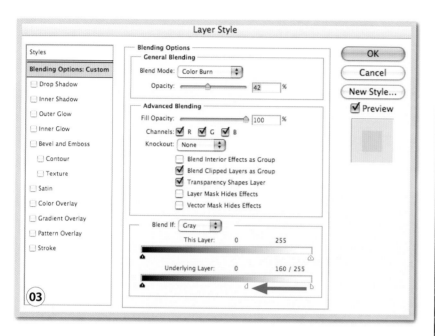

Focus on... duotone

Duotone technology has its routes in the printing industry, where a photograph would be printed with two inks – black and another colour. Photoshop (and a number of other digital-imaging programs) uses the same principle to add a subtle tint of colour to a monochrome shot, or extend a photograph's tonal range by using black and grey to describe it.

Display Photoshop's Duotone dialog box by first converting the image to Grayscale mode (Image > Mode > Grayscale) and then to Duotone mode (Image > Mode > Duotone).

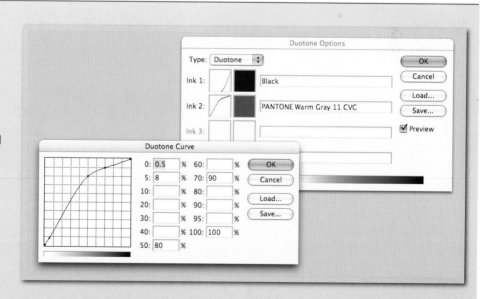

The colours to be used are specified here. It's best to start off with the darkest colour at the top and get progressively lighter. Click the coloured box to choose your colour from either Adobe's standard colour picker or from the calibrated Pantone range of colours. These mini Curves diagrams specify how

much of a particular colour should be applied to a shade of grey. The Duotone principle extends further than just using two inks. Choose either Tritone or Quadtone from this pop-up menu to extend the number of inks to three or four. If choosing the right

colour and fiddling about with Curves settings sounds a little too technical, click Load… and take advantage of the presets included with Photoshop. There are colour combinations here for high- and low-contrast images, as well as different colour tints.

Right: The Dodge and Burn tools are surprisingly flexible when the options for opacity and range are used to full effect.

Dodging and burning

Some of Photoshop's tools are so similar to those used in a wet-chemical black and white darkroom that they even have the same name. The Dodge and Burn tools make selective parts of a picture lighter and darker respectively. Dodging is the mono printing technique in which light is prevented from reaching the photographic paper by shading it, causing lightening of a region. Burning is the technique of directing extra light onto a portion of the scene, making it go darker.

The digital Dodge and Burn tools that are included with Photoshop work in much the same way, only they are much more controllable and flexible in what they can do. In this landscape, we can darken the sky, making the white clouds stand out, by selecting the Burn tool and running a soft, large brush over the area. The effect should be subtle, so lower the Exposure slider to around 10 per cent to get some control. Shadows was selected from the dropdown menu to avoid darkening any of the white clouds by mistake. The clouds were whitened using the Dodge tool, with Highlights selected in the dropdown menu at the top of the screen.

Left and above left: The Dodge and Burn tools can selectively darken or lighten parts of a scene.

Below: A soft, large brush works well for dodging and burning.

Right: The final image.

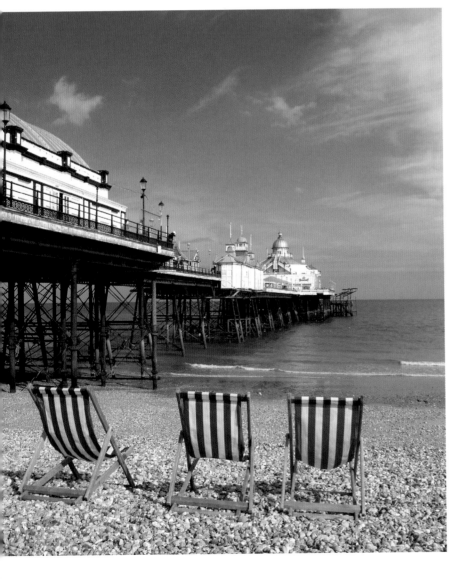

Digital lith printing

Lith printing is a specialist darkroom technique where grainy, high-contrast prints are produced by overexposing the print and using a very weak solution of developer to bring out the image over a long time. Lith prints have characteristically deep shadows and soft, delicate highlights. The results are striking, but notoriously unpredictable and time-consuming.

To recreate the effect in Photoshop, we must break down the image into its shadows and highlights and treat each differently before recombining them to form the finished image. This might sound complicated, but it isn't as hard as it sounds.

01 We'll start by removing the colour from the image in whichever way works best for that particular scene. Here, I've used the Image > Adjustments > Desaturate command.

02 Next, duplicate the background layer (Layer > Duplicate Layer) and name this 'clipped highlights'. ped shadows' (double-click the layer in the Layers palette).

03 With the clipped highlights layer active, select Image > Adjustments > Levels and drag the white-point slider to the left so that the highlights burn out and become white.

04 Next, temporarily switch off the clipped highlights layer by clicking its eye icon in the Layers

Below: A digital lith print with deep shadows, soft highlights and bold grain.

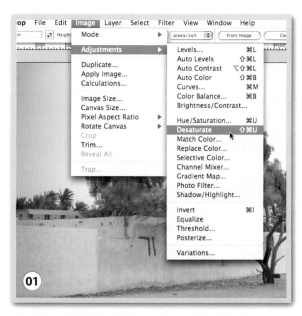

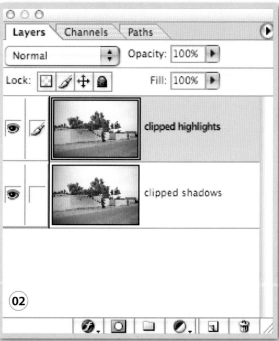

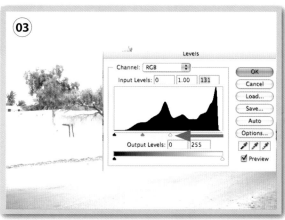

palette and make the clipped shadows layer active. Make another Levels adjustment, this time moving the black output slider to the right to decrease the overall contrast level and shift any black tones towards the grey end of the scale.

05 While we are working on the clipped shadows layer, we'll add some sepia tint to it. Select Image > Adjustments > Hue/Saturation and tick the Colorize box. Move the Hue slider around until you hit on a shade that looks good, then click OK.

06 Make the clipped highlights layer visible again – we'll add some grain to it, another characteristic of a lith print. Select Filter > Noise > Add Noise and tick the Monochromatic box. A value of 5 per cent in the Amount box should do it. Next Choose Filter > Sharpen > Unsharp Mask and wildly exaggerate the value in the Radius box. When you're done, click OK.

07 Finally, we'll merge the two layers together by changing the blending mode of the clipped highlights layer to Multiply. You can do this in the dropdown menu in the Layers palette.

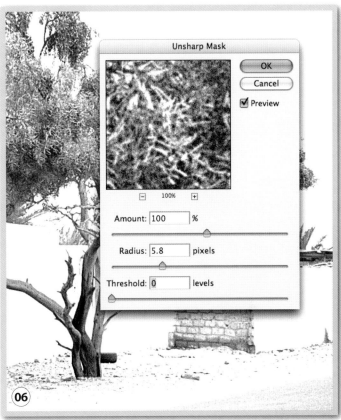

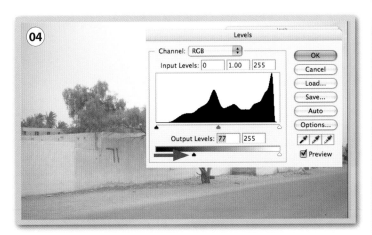

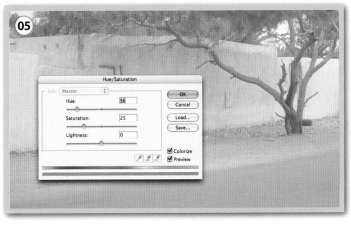

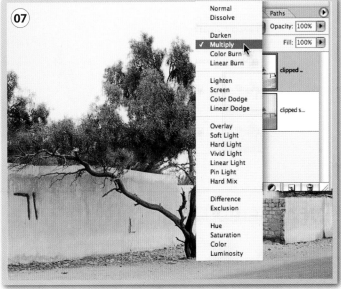

Outputting

If you believe what the manufacturers of printing paper are saying, we are not printing our pictures as much as we used to. However, nothing beats the feeling of seeing an image that you have slaved over hanging on a wall, beautifully mounted and framed, especially when the image has been printed to the best possible standard.

Traditionally, photographers could either send negatives or transparencies away to photo labs and pay (handsomely) for a print, or were faced with having to retreat to the darkroom, where a lot of skill was needed to produce a good-quality print. But nowadays, affordable inkjet printers make the process of obtaining a colour or black and white print easy – and what's more, they can be created in your own home in minutes.

In this chapter, we will explore the options available to photographers producing prints from their images, from inkjet printing at home to online and high-street printing at commercial photo labs. Traditional prints aren't the only products available, either. If you have never printed your pictures as part of a professionally bound photo book, then you should try it. This is a great way of showing off a collection of images, be it a set of holiday photos or a portfolio. Then there are canvas prints, or perhaps photographs on glass. The options are virtually endless.

Of course, these days, hardcopy items such as prints and books are not the only way of showing off your images. The Internet is a great tool for photographers, and you don't have to be a teenage snowboarding computer geek to begin exhibiting (and even selling) your pictures on the net using your own webpage. All the technology you need is built into Photoshop, and is just waiting for you to exploit it.

Printing images

Sooner or later we all want to make prints from our images. After all, prints are one of the best ways of sharing pictures with our family and friends and reminiscing over memories. Of course, if your pictures are really good, and you fancy yourself as a fine-art photographer, you can make large prints of your images that are ideal for framing and showing on your living-room wall. You could even sell them for other people's living rooms.

Inkjet printing

Printing at home offers one huge advantage over other methods of output: control. If the first attempt at a print is too dark or doesn't faithfully reproduce the colours in the image, a second (or even a third or fourth) print can be made. The flipside of this is that printing at home can be time-consuming, and there is a lot to learn if complete control over the printing process is the end objective.

By far the most popular method of printing at home is inkjet printing. There is a huge range of inkjet printers available on the market, with models ranging from the ludicrously cheap to the eye-wateringly expensive, but all of them work in more or less the same way: ink is transferred from cartridges to the printer's print heads, from where it is deposited onto the paper in tiny droplets to form the final image. The absolute minimum requirement for an inkjet printer is four types

of ink: cyan, magenta, yellow and black. Higher-end models have more than this and are able to print a more subtle range of shades and tones.

The great thing about inkjet printers is that they are relatively cheap to buy and can produce photo-quality prints in sizes ranging from 6x4in 'en-print' size right up to A3 (11¾x16½ in) and beyond. As with everything in photography, you get what you pay for. Expect more expensive printers to be able to output to larger sizes and with more ink shades for higher quality.

The way that an inkjet printer deposits ink onto the paper is key to producing a good image. Different papers require different inks, which is why it is important to regularly update your printer driver (the software that talks to the printer on behalf of your computer). As new papers are introduced, so descriptions of how the printer should handle them are introduced into the driver. Select the wrong paper type and the final image will be less than perfect, and could be completely unusable.

Dye-sub printing

Inkjets are not the only desktop units capable of producing high-quality photo prints. Dye-sublimation printers (dye-subs for short) work by heating up ink so it sublimes on to the media. The printers need a special type of paper and, because of their niche status in the market, the cost per page can be high.

Fortunately, quality and speed are high too and dye-sub printers have become popular with event photographers who need to produce prints quickly for an audience eager to buy them. The high quality comes chiefly from the transparent inks used in the process. With inkjet printing, cyan and magenta dots must be printed next to each other to give the impression of a blue dot from a distance. A dye-sub's transparent cyan and magenta dots can be overlaid on top of each other to give the same effect. It is because of this lack of a need to halftone or dither (to use the proper technical terms) that colours can be applied as smooth continuous tones, giving high-quality photo-realistic images.

Above: Inkjet is not the only option: dye-subs are an alternative.

Inkjet troubleshooting

Below are outlined some common problems with inkjet printing, along with some suggested solutions.

The prints have lines running across the page, perpendicular to the direction in which the paper is travelling.
One or more of the printer's print heads is blocked. Run the head- or nozzle-cleaning routine from the printer driver and print a test sheet to see whether this has cleared the blockage.

The prints have short lines running down the page, parallel to the direction in which the paper is travelling.
This can sometimes be caused by ink that has accidentally got on to the printer's roller and is coming off on the paper. Use a cleaning sheet – these are often supplied with packets of photo paper.

The prints lack punch. The colours aren't as bold as expected, and the ink doesn't appear to be dry.
Check that you have printed on the correct side of the paper. It might sound daft, but this is an easy mistake to make. The printable side of the paper is often the most bright white, but if you still can't tell, carefully put a corner of the paper between your moistened lips; the printable side will stick slightly.

The prints aren't as sharp as they could be.
Check that you are using the right type of paper, and that you have specified this in the printer driver. If your printer is putting too much ink on a matte-type paper, the ink can spread, making the dots broaden. This will give the impression that the picture is fuzzy.

There is garbled nonsense such as text characters and symbols on the print.
You are most likely printing with the wrong printer selected in the page set-up box. Go back and make sure the selection matches the unit you are using and try again. If the problem persists, turn everything off and back on again and consider reinstalling the driver software.

Right: Inkjet printers, such as the Epson R2400 here, can deliver superb results.

Printing from Photoshop

Printing directly from Photoshop or Photoshop Elements gives a photographer a lot of control over how the final image will appear on paper. From the size and orientation of the print, to its sharpness and colour accuracy, Photoshop lets you stay in control from start to finish.

There are many degrees of control available in Photoshop, from the nearly automatic to the mind-bogglingly complex. Let's try to steer a course through the middle of these extremes and establish a useful, but simple, workflow for making prints.

Print with Preview

Because of the costs involved (add up the price of the ink and paper and you'll be surprised), it pays to get a print right first time. Some of the most basic errors, such as outputting at the wrong size or resolution or with the image set to landscape instead of portrait, can be avoided by getting into the habit of using Print with Preview instead of the normal Print dialog.

When you are ready to print, select File > Print with Preview and you will be greeted with this dialog box (left). Lets have a look at the options available.

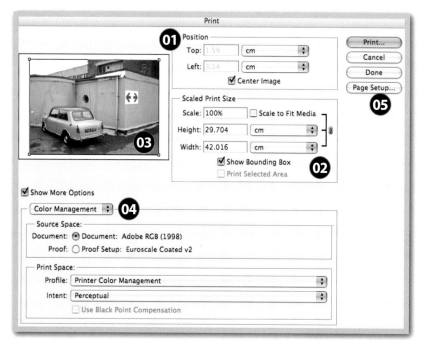

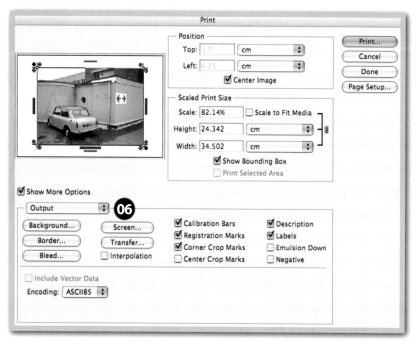

01 It is possible to accurately position the image on the paper, which is great if you are printing for a mount and frame, or making a greetings card, for example. Tick the Center Image box to position the image in the middle of the paper.

02 The image can be scaled from within Print with Preview by tapping the required dimensions into these boxes. Alternatively, drag the resize handles in the image-preview window.

03 The image preview shows approximately how the final image will look on printed paper. It is invaluable for spotting mistakes before pressing Print, such as the paper orientation being set to portrait instead of landscape.

04 Colour management is a thorny subject. These options tell Photoshop how to cope with colour when printing. We will look at how to manage colour properly with ICC profiles later (see pages 112–113), but if you are after a basic approach, select Document as the source space and set the print space to Printer Color Management.

05 It is possible to leave this dialog behind for a moment and make changes to the Page Setup settings. Note that by holding down Alt/Option, the Print Cancel and Done options change to Print one… (for a one-off quick print), Reset (to return all options to their starting values), and Remember (to save the options without closing the dialog).

06 Changing this dropdown menu from Color Management to Output reveals options such as Crop Marks – useful when trimming a print by hand.

Focus on... resolution

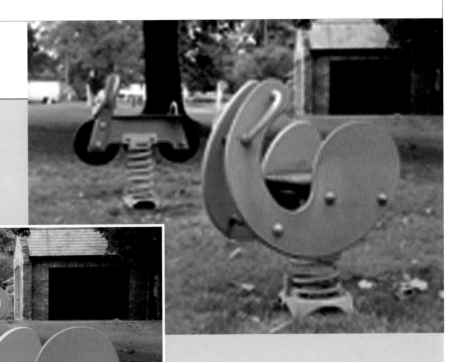

Left and above:
A comparison of a
high- and low-resolution
image printed at the
same size.

Below left: Photoshop's
Image Size dialog box.

Image resolution is a notion that many photographers new to digital struggle with, but once the concept clicks you will wonder what the problem was. Put very simply, the resolution of a digital photograph is just the number of pixels in a specified physical distance. By convention, this is usually defined as the number of pixels per inch – you may have heard the term 'ppi' mentioned by experienced digital photographers.

The more pixels that are crammed into an inch, the smoother and sharper the image will appear. But resolution is intrinsically linked to physical size: as an image's resolution is increased, so its size gets smaller. Likewise, as an image is increased in physical size, the lower its resolution (and hence quality) becomes. This relationship is the reason that camera manufacturers are always striving to produce cameras of higher and higher pixel counts. The basic truth is that the more pixels comprise a photograph, the bigger high-quality prints can be made.

Open Photoshop's Resize dialog box (Image > Image Size) to see this relationship in action for yourself. Make sure the Resample Image box is not ticked and make the image dimensions bigger; you will see the resolution drop as you do so. A good rule of thumb is to try not to let the resolution drop below 200ppi for images that are going to be printed.

Image Size

Pixel Dimensions: 5.49M

Width: 1600 pixels

Height: 1200 pixels

OK

Cancel

Auto...

Document Size:

Width: 6 inches

Height: 4.5 inches

Resolution: 266.667 pixels/inch

☑ Scale Styles

☑ Constrain Proportions

☐ Resample Image: Bicubic

Printing and colour

One of the headaches of outputting images is trying to match the colours seen on a photographer's computer monitor with those in the final print. Colour management, as this is known, is a huge subject. It involves trying to be as consistent as possible throughout the digital workflow: from taking the picture in-camera, through editing it on screen to outputting it on paper. The frustrating thing about colour management is that, ultimately, a printed image can never look identical to an on-screen image – it can only approximate it. There are two reasons for this.

The first is that a printed photograph can be seen by the human eye because of light reflected off the surface of the paper, whereas an image on a computer screen consists of transmitted or emitted light from the monitor. This is a huge difference (akin to the way a print and a transparency are viewed in traditional photography) and means the vibrancy of colour seen on a bright, high-end computer screen will rarely be matched by dyes on paper.

The second, and most important reason, is that

Above and left: The same doorway taken in two different colour spaces: on the left, Adobe RGB (1998) and above, sRGB. Each is a different way your camera can see colour.

the basic colours that are mixed together to form the image differ from the screen to the print. On a screen, red, green and blue are mixed to form the colours needed to describe a photograph, whereas on paper, cyan, magenta, yellow and black are used. These two colour modes – known as RGB and CMYK – are capable of displaying different collections, or gamuts, of colour.

Colour space

Just when you were thinking 'this all sounds quite complicated', another aspect comes along to makes things even worse. Even within the RGB and CMYK colour modes, devices can differ in the way they perceive colour, and no device perceives colour in the same way as the human eye. For instance, the way your camera perceives colour is not the same as the way your screen displays it or as Photoshop understands it when editing. Each device has a colour space – essentially a description of how it sees colour.

So how do we make sense of this mess? Well, fortunately the good people at the International Color Consortium (ICC) have done that for us. All modern

digital-imaging equipment has an ICC colour profile that describes the colour mode and colour space in accurate detail. Software such as Photoshop can convert between known colour spaces, preserving the appearance of colour as it goes.

We will ignore colour profiles that are unique to individual cameras, scanners, and so on for now and concentrate on the two most common colour profiles: sRGB and Adobe RGB (1998). Most cameras offer the choice of shooting in either one of these colour spaces, but photographs that are destined for an inkjet printer will do best in Adobe RGB (1998). The sRGB profile is better for images to be sent away to be printed and for those pictures destined for the web.

With all this in mind, one of the first routes to colour consistency is to set your camera to shoot in Adobe RGB (1998) (consult your camera's instruction manual for advice on how to do this) and to set up Photoshop to edit in this colour space by default. Do this by selecting Edit > Colour Settings and selecting Adobe RGB (1998) from the RGB working spaces dropdown menu. Also tick the Ask when opening the box under Profile mismatches. This will give you a chance to take charge of things when opening an image that is not in Adobe RGB (1998).

Right: Switch on the Gamut Warning in the View menu for a simple way of telling whether the picture you are editing on screen contains colours that are outside your printer's gamut.

Calibrating your screen with an external device

Colour calibrating your screen is a crucial part of achieving colour consistency. If you want to achieve consistent results, particularly when your images are likely to be output by different printers, then calibration is the only way. We saw back in Chapter 1 how to do this by eye (see pages 16–17), following the automated wizards included with Windows and Mac OSX. Although these methods are fine for many instances, they are still open to error as our perception of colour is subjective – who is to say that the colour one person perceives and describes as bright red appears exactly the same to someone else?

We can get round this by using a colorimeter – a device that analyzes the colours and calibrates our computer's screen accordingly. These devices, such as Pantone's Huey, shown right, look at coloured spots on the screen, which are generated by the software, and calibrate them accordingly.

Printing with ICC colour profiles

We have seen how setting your camera to shoot in the same colour space in which Photoshop is editing can help with colour consistency – and calibrating your monitor by creating a colour profile is also a big bonus – but how does this all work together? Here's a workflow that shows how Photoshop becomes the centre of colour consistency when it comes to making prints.

This is an advanced technique that replaces the colour management normally carried out by your printer driver software. You might find it is more work than relying on automatic, but it also produces more consistent results.

01 To begin with, if the photo being worked on is not in the Adobe RGB (1998) colour space, we need to make sure it is. This image was taken in the sRGB colour space, so Photoshop alerts me to this. The following choice has to be made: go with the RGB

profile built in to the file; use the Adobe (1998) profile instead; or ditch the profile and assign one manually later. We'll go for the latter option: click Discard the embedded profile, and hit OK.

02 Now select Edit > Assign Profile and choose sRGB from the dropdown menu. At the moment, we are assigning a colour profile to the image so Photoshop knows where to start from.

03 Now select Edit > Convert to Profile and choose the colour profile to be used for editing the photograph – Adobe RGB (1998). Click OK and Photoshop will convert the file from one colour space to the other.

04 Carry out any editing on the picture and save a copy in the Adobe RGB (1998) colour space. To convert to the printer's own colour space during output, select File > Print with Preview and make sure the Color Management button is clicked and these options are shown. Select Let Photoshop Determine Colors, pick the printer profile that best describes the set-up you are using, and set the Rendering Intent to Relative Colorimetric, with Black Point Compensation box checked. When you're done, hit Print.

05 Set the appropriate quality and paper type options, then switch off all colour management by the printer driver. This is very important. If left on, the colour correction will be applied twice and the results will look awful!

01

Embedded Profile Mismatch

The document "P8132403.JPG" has an embedded color profile that does not match the current RGB working space.

Embedded: sRGB IEC61966-2.1

Working: Adobe RGB (1998)

What would you like to do?
- ○ Use the embedded profile (instead of the working space)
- ○ Convert document's colors to the working space
- ● Discard the embedded profile (don't color manage)

Cancel OK

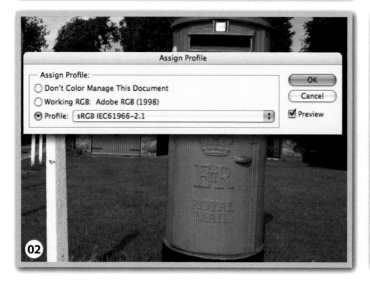

02

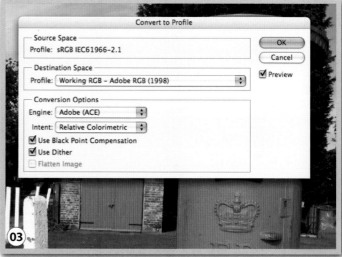

03

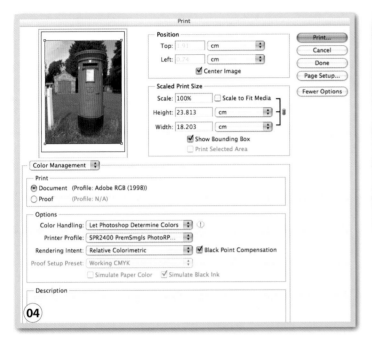

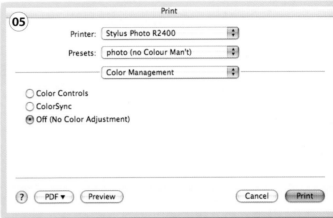

Focus on... printer profiles

Printer profiles do much the same as any other digital-imaging profile – describe how to produce colours that correspond with other devices in the digital photography workflow. A printer profile will tell a printer how to produce colours that are as near as possible to those seen on screen and those captured by the camera in the first place.

Unfortunately, though, it's not enough to have a single profile for a single printer; there are simply too many variables. Using a different type of paper, or changing the printer's quality setting, can mean that more or less ink falls on the paper, and this must be accounted for in the printer profile. It's therefore not uncommon to find dozens of printer profiles for a single model, each for a specific combination of settings and paper type. Printer profiles are usually installed with the software that accompanies your printer, but it's worth keeping an eye on your printer manufacturer's website, as they are often updated with new profiles as they come out. Note that profiles must be put in the right location in order to be recognized by your system, and these change according to the operating system you're running.

• Windows 98/2000 users should copy new profiles to the following directory:
Windows/system/color.

• Windows XP users should copy new profiles to the following directory:
Windows/system32/spool/drivers/color.

• Mac OSX users should copy new profiles to the following directory:
HD/Library/Colorsync/Profiles.

It's also possible to have custom printer profiles made for your specific set-up. It's a costly and time-consuming procedure, but if you are determined to produce high-quality fine-art prints, and the printer manufacturer's own profiles are not good enough, then it might be a sensible route Companies offering such a service, such as Pantone (www.pantone.com), will supply you with a test pattern that you print on your chosen paper at your desired quality setting. This test pattern is sent by post to the manufacturer who in turn supplies a custom printer profile. Clever stuff!

Online printing

Many companies have set up in the online printing trade. The concept is simple: the photographer uploads his or her pictures to the printer's server using the Internet. The printer then makes the prints according to the photographer's instructions and delivers the prints by post. Simple! But online printing offers much more than that. Digital photographers aren't limited to prints anymore. Huge posters or sophisticated canvas prints can be ordered too, as can t-shirts, mugs, mousemats, calendars and greetings cards. The range of items available from online print providers is remarkable.

Photo books

One of the slickest ways of presenting your pictures is the photo book. These professionally printed and bound books are a great way of seeing your photography published as a coffee-table book for a reasonable price. Most of the online processors offer such a service, and let you design the book on their website using a series of predesigned templates. These can range from the extremely sophisticated to the downright tacky.

Photoshop is one piece of digital-imaging software that offers online print ordering – including photo books – from within the application. Using Bridge, it is possible to select which images you wish to include in the book and let the software upload them to Kodak's servers, where you can put a photo book together online. Apple's iPhoto does a similar job, except it lets you design the book on your own computer and only uploads the final pages, as PDF files, to the printer.

As well as being a good vehicle for your own photography, photo books also make great gifts. Know someone who has just got married? Why not collect photographs from all the guests and put them together as a book for the happy couple to find when they get back from their honeymoon? Or surprise a friend with a book full of their most embarrassing moments as a birthday present.

Left and right:
The templates offered by Apple's iPhoto and Aperture applications are flexible and well put together, offering the ability to write text as well as lay out pictures in a number of ways.

Far right: Photo books make great mementos.

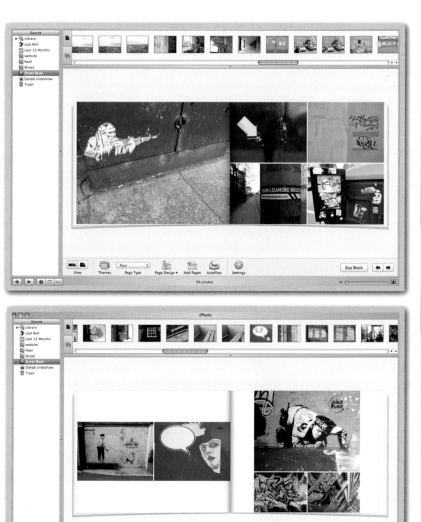

Canvas prints

A canvas print on the wall can look really special, and until quite recently the only way to get one was to pay handsomely at a professional photo lab. Thanks to digital printing, however, a canvas print can be yours for considerably less, and you can use the services offered by online printers to order them too.

A canvas print can turn your photographs into a stunning work of art.

Putting your images on the Internet

These days, printing pictures is not the only way of outputting your pictures. The Internet revolution means that digital photographers can publish their pictures to the whole world. With a website, anyone, anywhere can see your pictures at any time. They can comment on them, rate them, and even buy prints of them if you are set up to sell on the web.

Automated web photo galleries

Once upon a time, writing your own webpage was time-consuming and technical, but now most photo-editing software can do it for you. Photoshop and Photoshop Elements produce some great-looking websites in a variety of styles. To begin the process in Photoshop CS2, either: gather all of the pictures you would like to publish into a directory by themselves and choose File > Automate > Web Photo Gallery in the main Photoshop application; or select the pictures to be web-published using Bridge and choose Tools > Photoshop > Web Gallery. The Web Photo Gallery dialog box is rich in features, so it pays to spare some time to explore it.

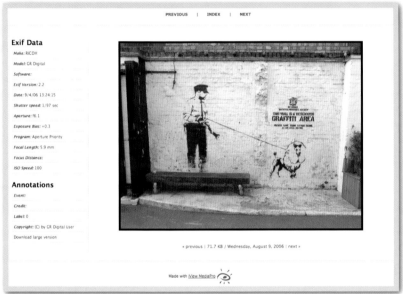

Above and right: An automatic web page design from Photoshop CS2 (top) and one from iView MediaPro (right).

01 Select the website style here from the dropdown menu. The presets in Photoshop and Photoshop Elements are a little different from each other, but both applications offer a good selection.

02 Specify the location of the image files that are to be included in the website, and the location where Photoshop should store the website pages once they are created.

03 Set options including the site's name and creation date, as well as setting the colours used on the page and the names, captions and sizes of each image.

Customizing online photo album templates

The templates that Photoshop uses in its Web Photo Gallery are customizable if you know a bit of HTML – the language that web pages are written in. It is best to work on a copy of one of the existing templates so that if anything goes wrong you don't lose one of the built-in designs forever!

Find the existing page designs in the following locations, according to the operating system you are using.

• Windows: Program Files/Adobe/Photoshop CS/Presets/Web Photo Gallery
• Mac OS: Applications/Adobe Photoshop CS/Presets/Web Photo Gallery

Choose the folder containing the template and quickly make a copy (either by clicking it and choosing Copy then Paste in

Windows Explorer, or by clicking it and choosing Duplicate in the Mac OSX Finder). Now open the template in a text editor or web-authoring application to edit the HTML. Certain terms, called Tokens, are shown sandwiched between % symbols. These represent the details entered in the Web Photo Gallery dialog box, or copied from the image file. For example, in the final webpage, %TITLE% will be replaced by the title of the webpage, while %PHOTOGRAPHER% represents the credit attributed to each picture. A full list of available tokens is listed in Photoshop's Help files (Help > Photoshop Help).

Using these tokens in combination with some HTML to style the page, it is possible to build heavily customized web galleries, with your own logo or branding on them. This is great for presenting online portfolios to clients if you are dabbling in the professional side of photography.

It's worth investigating how to customize Photoshop's web galleries to achieve a look of your own.

Creating images for web and email

Photoshop can help you save images in a format that is suitable to upload to the web yourself, either through an automated online service such as Flickr (www.flickr.com), or to your own managed webspace using an FTP application.

When installing Photoshop on your PC or Mac, a second application, called ImageReady, is also installed. ImageReady is a graphics application that is similar in many ways to Photoshop, except it is specifically designed to create images for webpages. It is a full-featured piece of software, and describing its every tool is beyond the scope of this book. Instead, let's look at a piece of its functionality that has made its way back in to the main Photoshop application, and into Photoshop Elements too.

Save for Web

Photoshop's Save for Web feature is designed to resize and compress photographs for uploading to the web or sending by email. It is a great help if this is something you are going to be doing a lot, as it even gives a preview of what the image will look like after it has been compressed (in the case of a JPEG file) or had the colour stripped out of it (in the case of a GIF).

Open the image in Photoshop that you would like to put onto the web or email and, when you have finished editing it, select Save for Web from the File menu. You will be presented with the Save for Web dialog box that, by default, shows the original image on the left-hand side and a preview of the web-optimized image on the right.

01 The Original window shows the file as it currently appears in Photoshop.

02 The Optimized window shows the images as it will appear after the currently selected JPEG compression settings have been applied to it.

03 Select the output file format and the degree of JPEG compression here, and save or recall often used settings to save time.

04 The Image Size tab contains controls for resizing images as they are output. Enter the new dimensions in the Width, Height or Percent boxes and leave the Constrain Proportions box ticked to ensure the picture keeps its aspect ratio. The method of resizing can be

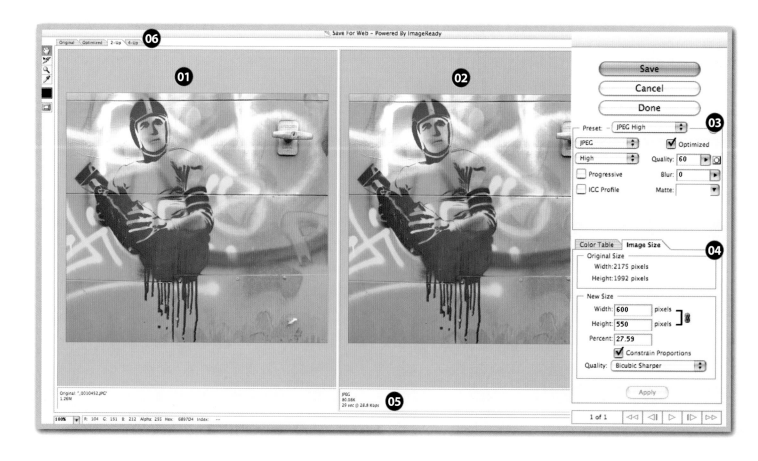

selected from the Quality dropdown menu. Bicubic Sharper gives perhaps the best quality result when decreasing an image's size, but takes longer to process.

05 These figures give an estimate of the final size of the optimized file and the time it will take to download on another user's computer.

06 If you want to compare the effect of a number of different compression values, click the 4-Up tab to have three JPEG previews and the original file showing at once.

If you didn't resize the image prior to engaging the Save for Web function, this is the first thing you will want to do. Click the Image Size tab to bring it to the front and enter the new dimensions for the image, which will depend on the web page it is being uploaded to. For emailing, 500 pixels is a good value, although this is only a guide.

By adjusting the Quality option in the top right-hand corner of the screen, it is possible to change the size of the final file, which is previewed underneath the optimized image. Be wary of letting this value drop very low, as too much compression can have a detrimental effect on the way your photograph will appear. Alongside the file size figure is an estimate of how long the image will take to download on a computer connected to the Internet with a 28.8kbps modem – the minimum specification likely to be around these days. To change this specification, right-click on the image and select a new modem speed from the list.

Although Save for Web gives the option to work with JPEG, GIF and PNG files, photographers should stick to JPEGs when outputting their images. GIF files have only 256 colours and are used mainly for images that contain solid areas of colour, such as the graphics that make up the designs of the webpages themselves. Support for PNG files is still not as broad as for JPEGs at this time.

When you are happy with how the image looks, hit Save to give the file a name and specify its location. Then use your favourite FTP application to upload the file to your website, or attach it to a mail message to send it via email.

Focus on... colours on the web

If the colours in a picture look washed-out in the Save for Web dialog box, it is probably because your image is not in the sRGB colour space. At present, not many web browsers (including the market-leading Microsoft Internet Explorer) can recognize which colour space an image has been saved in, so they default to sRGB. Because of this, it is best to save your images in this colour space to begin with.

In the main Photoshop application, convert an image to the sRGB colour space before selecting Save for Web but choosing Edit > Convert to Profile. Set sRGB as the Destination Space and click OK.

To convert a whole batch of files to the sRGB colour space, if you are uploading a lot of images at once, for example, use the Image Processor, which can be found in File > Scripts > Image Processor.

sRGB is a better colour space to use for online images.

The next steps

The best thing about digital photography (and often the most annoying thing, too) is that there is always someone who knows more about taking, processing and manipulating images than you do. In this chapter, we will look at some more advanced Photoshop techniques, which will hopefully inspire you to carry on learning by yourself. After all, one of the best aspects of digital photography is that it encourages photographers to experiment.

Rather than taking a comprehensive look of all of Photoshop's advanced features (which would take another 300 pages), we will cover just a few themes, such as creating a workflow to help stay organized, obtaining the perfect white balance in Raw files, and working with high dynamic range (HDR) images.

It is important to realize that none of the techniques we have encountered so far is meant to be used on its own. The real strength of digital photography comes from combining different methods to achieve a good-quality end result, and in this chapter we will look at this concept more closely. A picture may need its contrast, colour balance and sharpness all working on, for instance. Or you may find yourself applying different adjustments to different parts of an image, using the selection or masking tools to isolate distinct areas.

It is down to the skilled digital photographer to select which techniques to use, of course, and this is where experience and practice come in. There are no absolute right or wrong ways to work on a photograph. However, in time you will develop your own set of preferred techniques that will result in a unique style in much the same way as in-camera techniques do.

Learning digital photography is very much a journey without a final destination. And, as with any journey, it is important to look around once in a while and enjoy the view.

Digital workflow

Digital photography means that we take many more pictures than when shooting film was the most popular way of taking pictures. We aren't afraid to experiment and try out new ideas. It is easy to keep your finger on the shutter release, confident that you will be able to pick a winning picture when you get back home, without worrying about how much film is left and how much it is going to cost to develop and print.

The downside of this, however, is that the sheer number of picture files a photographer is capable of generating in a year can quickly clog up even the most powerful computer – and if you're not careful, finding a specific picture from the chaos of files on your hard drive becomes almost impossible.

So what's the solution? Develop a workflow. A workflow defines the way a photographer works in his or her studio or office. It describes how a Raw or JPEG file comes off their camera, onto their hard disk, is processed, backed up, stored, and output. Of course, each photographer's needs are different, and hence so are their workflow solutions, but it is useful to see how others function when thinking about how you should work yourself. Here's a look at how I keep the many gigabytes of images that I shoot every year organized and under control.

Instigating a workflow process is all about consistency – doing the same things every time from file transfer, through editing to output, storage and back-up. Although it may look as if being this organized takes extra work, it will actually save a lot of time in the long run.

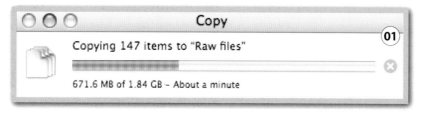

Right: A Digital Asset Management application such as iViewMedia Pro or Extensis Portfolio will help you stay organized.

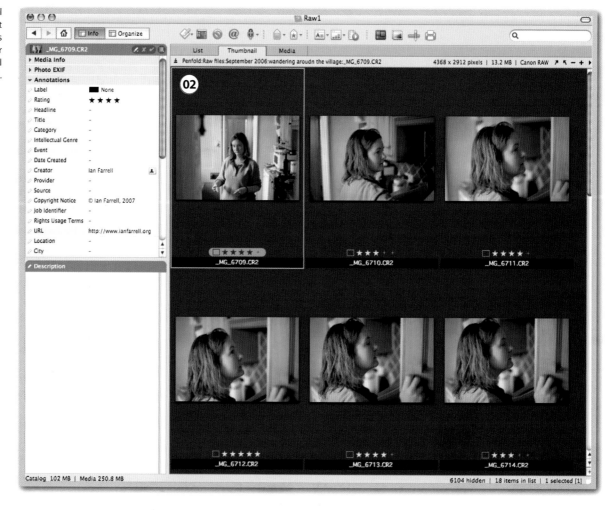

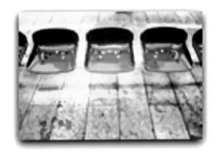

Venice_DSC0037A.tif

My workflow

01 After a shoot, I transfer my Raw files to a dedicated area on a large external hard drive using a FireWire card reader. I split this Raw file repository (as I call it) into subfolders by date: January 2007, February 2007, and so on.

02 Using a Digital Asset Management application, I add basic metadata to all of the images. This includes copyright information, contact details, and so on, as well as very brief location data for each set of images. I then rank the pictures from one to five stars, according to which I like the best. At this point I also make a back-up of the Raw files on a DVD – they are the closest thing digital photographers have to an original negative, after all.

03 When I have decided which images to work on further, I process these Raw files using the Raw conversion package Capture One, from digital back manufacturer Phase One. I set the application up to write the processed 16-bit TIFF file in a directory called Work in Process on my computer's main hard drive. This is a temporary location for the file while it is being worked on. I will delete it later to save space. At this point, the file name consists of a tag for me to recognize the image by ('Venice', for example), the number assigned to the file by the camera (such as '_DSC0037') followed by a letter to signify the version of the file, starting at 'A'.

04 Now I open the file into Photoshop and carry out any editing steps that are needed. I save the finished, unsharpened document in a directory simply called 'Finished Files', using the same file-naming convention and making sure I have added a full set of metadata, including a caption and keywords, so I can find it again. This directory is backed up once a week onto a 250GB external hard drive that I keep at a friend's house for security.

05 If the picture is to be printed, I use this version, in the Finished Files directory. I can find the photograph I'm looking for with iView Media Pro, searching by date, keyword and for the file's description.

Left: Setting white balance manually is much more accurate than relying on automatic settings, and will result in better images.

rest of the pictures. At the Raw conversion stage, the first thing to do is open all of the files in Camera Raw at once. This is possible from Bridge: select the files to open and right-click on one of them. Select Open in Camera Raw.

03 The Camera Raw interface should appear, with all of the files shown as thumbnails down one side. Now for the clever bit: find the frame showing your subject holding the grey-card reference and select this, by clicking on it, so it shows in the main window. Then click Select All to make the other files active too.

04 Choose the White Balance tool from the toolbar at the top left of the screen and click on the grey-card reference to set the white balance. Because all of the images are selected, Camera Raw uses this white balance setting for all of the frames in the shoot. Now you can go through and process frames individually while being confident the white balance has been set accurately on each of them.

Advanced white balance technique

Setting white balance manually on-camera is always better than sticking with automatic white-balance mode, which can get things very wrong if there's no white in the frame to act as a reference point. But even better is shooting in Raw mode and not worrying about white balance until you get home and process the files. Working in this way enables white balance to be set much more accurately, on a sliding scale of almost infinite possibilities. In contrast, a camera may have only six or so settings.

Using Photoshop's Camera Raw plug-in, it is possible to set the white balance for a picture by clicking an area that is known to be a neutral grey colour. It is also possible to apply the white balance setting from one frame to all others shot under those conditions. Combining these two techniques gives us a great way to get white balance spot-on for every frame.

01 The first step is to photograph your subject with a grey card (or similar device) in the frame. Without a reference like this, it is impossible to know whether you are working towards a truly neutral result. Remember to set your camera to shoot Raw files; this technique will not work with JPEGs.

02 With that out of the way, continue to shoot the

01

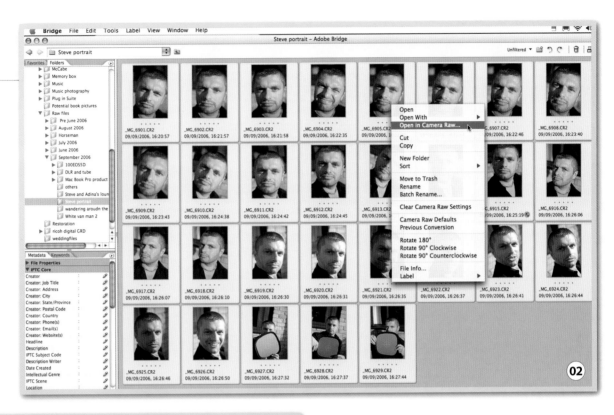

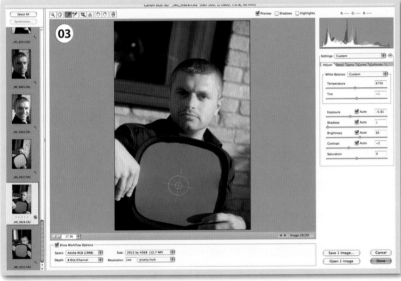

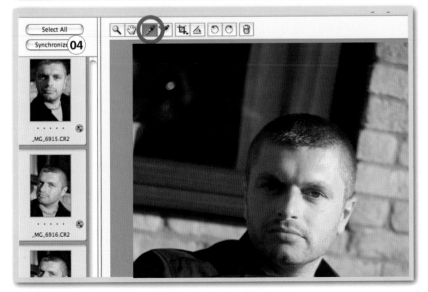

Focus on... synchronizing between Raw files

It is possible to copy more settings than just white balance by clicking on the Synchronize button. This is useful when the same adjustment has to be made to a number of files, as a lot of tedious repetition can be avoided.

To use the Synchronize function, simply make the required changes to one of the files, click Select All to highlight the other thumbnails, then click Synchronize. A dialog box will appear allowing you to specify which properties are shared between files.

Non-destructive editing

We have come across a number of ways to edit photographs in Photoshop so far, but nearly all of them have relied on permanently altering the pixels in the document. This effectively destroys the original in the process and means that if you want to go back to a previous state you must rely on the History palette. This is fine to a point, but there are two key problems with History. The first is that it remembers only so many actions (20 by default), and it is easy to fill this buffer when applying lots of edits with, for example, the Clone tool. Do this and you won't be able to leap back and change something that happened 40 or 50 edits ago.

Right: To go back and change the Levels adjustment that was applied to this image, we must undo all the operations that came after it, including some precision work with the Clone Stamp tool.

The second problem is that History is linear. This means that to undo an operation ten edits ago, you must also undo the nine operations that came before it. This is annoying as well as wasteful and inefficient. To get around these kinds of issues, we must find a way to edit an image non-destructively – that is, preserving the original pixels in the image even when editing.

The best way of working non-destructively in Photoshop is to use layers in your editing. This way, the original image can stay put in the background layer while other layers above it hold the edits. The layers stay separate regardless of how many operations are carried out, and because they can be edited independently it is possible to remove a Levels adjustment made in its own layer while leaving everything else in place.

Key to this way of working are Adjustment Layers. These differ from normal layers in that they don't hold editable pixels but rather contain colour and tone modifications, such as Layers, Curves and Hue/Saturation adjustments.

It is amazing how many of Photoshop's tools can be used in this way. Let's look at how some common techniques can be adapted.

Levels

Using a Levels adjustment layer to tweak the brightness and contrast of an image is very similar to using the Levels command in the Image > Adjustments menu. Select Layer > New Adjustment Layer > Levels (or select Levels from the Adjustment Layers shortcut menu in the Layers palette) and you will be presented with the familiar histogram and sliders. Make your adjustment and click OK – Photoshop will add the modification as a new layer above the background layer. This can be revisited at any time by double-clicking the adjustment layer icon.

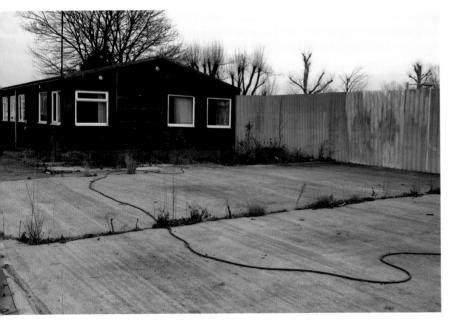

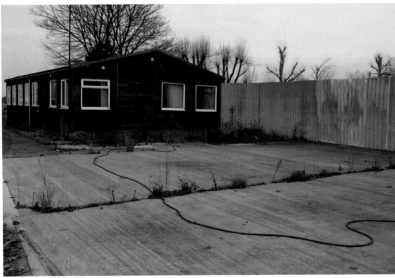

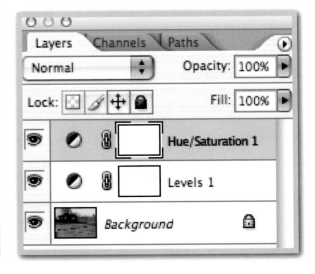

Cloning and healing

When removing unwanted detail from a digital photograph, using Photoshop's Clone Stamp and Healing Brush tools is definitely the way to go. However, making the edits on a different layer to that which contains the background image also gives all kinds of advantages. For a start, the process is non-destructive, meaning the pixels in the original image are preserved. Additionally, this also means that the cloned details can be edited themselves through Levels or Hue/Saturation adjustments, or even tidied up with the eraser or paintbrush tool.

Cloning and healing in this way is easy to do: simply create a new layer to contain the edits, make sure it's active in the layers pallet, and tick the box marked 'Sample All Layers' to make sure Photoshop copies from all the layers in the document. And if there are layers in the image you don't want to sample from, you can always turn them off temporarily in the layers pallet by clicking the eye-shaped visibility icons to the left of the layer name.

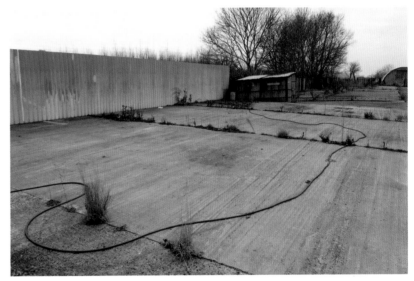

Creating a new layer and using Photoshop's Clone Stamp and Healing tool are the ideal way to remove unwanted details from a digital image.

Non-destructive black and white

Adjustment layers don't affect just one layer, but rather all of the layers below them. Let's see how this concept works by exploring a non-destructive method of producing a black and white image. This involves using a Hue/Saturation adjustment layer to take all of the colour out of a photograph, before using a Curves adjustment layer to make some tonal adjustments and a Solid colour layer to produce a sepia tint.

01 The original colour image.

02 Insert a Hue/Saturation adjustment layer by selecting Layer > New Adjustment Layer > Hue/Saturation. When presented with the Hue, Saturation and Lightness controls, drag the Saturation slider all the way to the left to remove the colour from the

picture. Click OK and you should notice this new layer in the Layers palette.

03 The picture looks a bit flat, so we will enhance the contrast with a Curves layer. Choose Layer > New Adjustment Layer > Curves and make an S-shaped curve to brighten light tones and darken shadows.

04 To tint the image we will insert a Fill layer. Select Layer > New Fill Layer > Solid Color and choose a

Right: Using a Hue/Saturation adjustment layer, we can remove colour from the background layer.

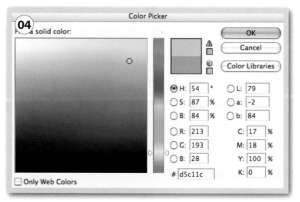

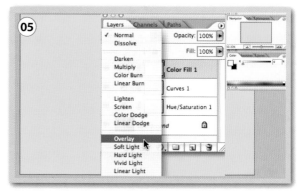

(07)

Left: A solid yellow colour layer with the blending mode changed to Overlay produces a tint.

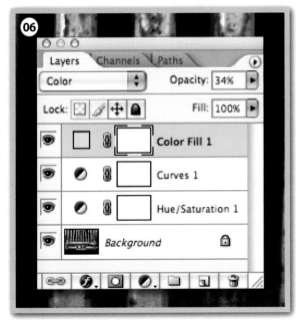

(06)

Focus on... Aperture and Lightroom

Apple and Adobe offer non-destructive editing of digital images in the form of their applications Aperture and Lightroom. Each works very similarly to let photographers work with Raw files as if they were normal JPEG or TIFF files, editing them non-destructively, seemingly without conversion.

The applications work by storing any edits as information in a database. This database also stores the Raw files themselves, but keeps them unchanged. Every time a file is reopened, the software reapplies the changes, giving the impression the image was saved in this way, when in fact it was never altered. Changes can be revisited and deleted at any time and the Undo History is not linear, as it is in Photoshop.

Applying changes to Raw files that might be 20–30MB in size in real time is quite a task for a desktop computer, and both Aperture and Lightroom need a fair amount of processing power to run. But as PCs and Macs become more powerful, expect this way of working to catch on.

Apple's Aperture software provides non-destructive editing of Raw files, without having to convert them first.

colour from the Color Picker dialog box that appears. Click OK and you will see a solid colour obscuring your image completely.

(05) To tint the monochrome image underneath with the colour in the Fill layer, change its blending mode to Overlay. Dial down the opacity if the effect is too strong.

(06) The great thing about this method is that the Curves adjustment, the tint colour, and even the degree of desaturation can be revisited at any time, completely independently of each other and the original image underneath.

(07) The finished, tinted black and white image.

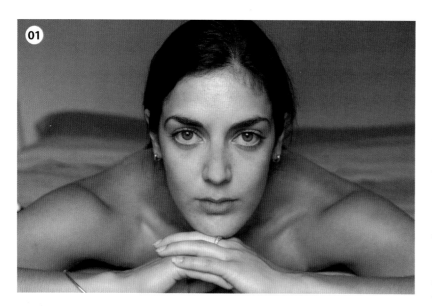

Cross processing

In film photography, cross processing is the practice of putting a film through the 'wrong' type of chemistry – for example, developing an E6 slide film in chemicals meant for C41 print film (or, less commonly, developing a C41 print film as E6 slides). This results in hugely exaggerated contrast and saturation and wild – if unpredictable – colour casts. Cross processing is popular with fashion photographers seeking a different look for their pictures. In fact, the technique suits people photography well, with skin tones rendering as a smooth creamy colour.

One problem with traditional cross processing is the unpredictable nature of the results. The look and feel of a cross-processed picture depends completely on the type of film being used (Kodak Elitechrome and Fuji Velvia will defer massively, for instance, even though they are somewhat similar when processed normally) and the lab doing the processing. Recreating the effect digitally is one way around this unpredictability.

The non-destructive approach

Using adjustment layers to manipulate an image non-destructively is good for digital cross processing, as it allows small adjustments to be made in hindsight if the effect doesn't suit the subject as the photographer wants it too. We will use simple levels adjustments in the individual red, green and blue channels to enhance contrast and introduce a colour cast at the same time.

01 Here's our starting picture. The first thing to do is insert a new Levels adjustment layer by selecting Layers > New Adjustment Layer > Levels or choosing Levels from the Layers palette shortcut menu. The familiar Levels dialog box should appear.

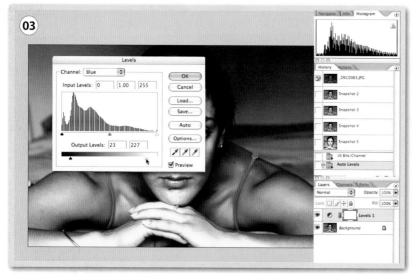

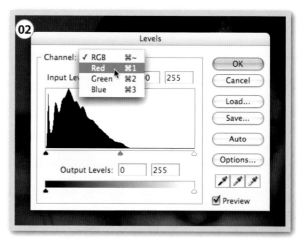

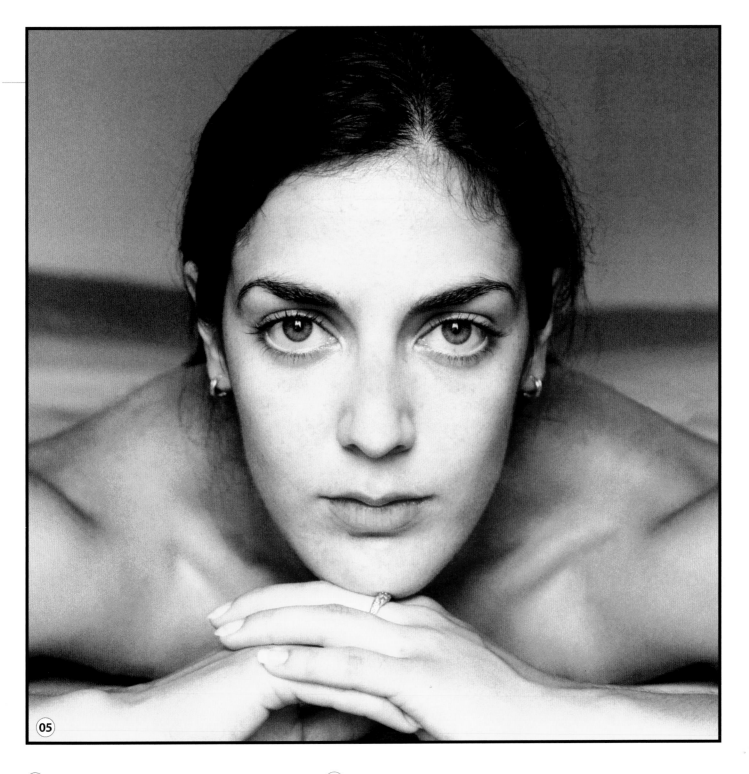

(05)

02 Select the Red channel from the dropdown menu and increase the contrast by bringing the highlight and shadow sliders in slightly (5–10 pixels) towards the centre of the histogram. Do the same for the Green channel, moving the highlight slider even more towards the middle (10–15 pixels).

03 For the Blue channel, reduce the amount of blue in the shadows and highlights by moving the output sliders in towards the middle of the histogram. Go back to the composite channel (RGB) and increase the contrast a little if it's needed. Then click OK. You can always come back to the adjustment layer later.

04 Add a yellow cast to the image by inserting a Fill Layer (Layer > New Fill Layer) containing a light yellow colour. Next, change the blending mode of this layer to Multiply or Overlay – whichever works best for the image you are working with. You can reduce the opacity of this layer if the colour cast effect appears too strong.

05 I cropped the final picture and added a border that I made by scanning an old medium-format negative. I also added a bit of noise (Filter > Noise > Add Noise) to simulate the increased film grain that usually results from cross processing a film.

Above: The final image: reproducing a cross-processed effect digitally has given a pleasing warm cast to the image that flatters the subject.

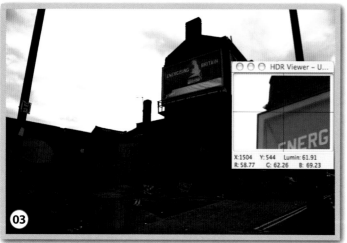

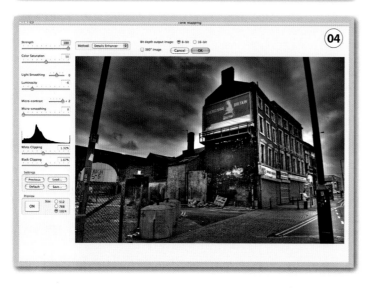

HDR images and 16-bit images

High dynamic range (HDR) imaging

As we saw earlier in chapter two, when we developed a digital ND grad filter, successfully recording extremes of light and dark on camera can often be difficult. Digital cameras just don't have the dynamic range of the human eye and photographers are often presented with a choice: record detail in the shadows or in the highlights, but not both.

Layer masks and other tricks can help, but they are fiddly to apply and don't always work. Over recent years a new digital method has come along to help photographers conquer this problem. High dynamic range imaging (or HDR, as it's more commonly known) involves producing multiple images from the same viewpoint, but different exposure settings, and merging them together afterwards on a PC or Mac. Photoshop gained the ability to do this in version CS2 (the command is tucked away under the File > Automate > Merge to HDR menu), but there are better applications on the market, such as Photomatix from HDRSoft.

Generating the source images

Producing the photographs from which an HDR image will be made can be done in one of two ways. Firstly, at the time the picture is taken a photographer can vary the exposure between frames, either manually or using their camera's auto exposure bracketing facility (AEB). The advantages of this technique are that the results will be of the highest quality, and should not be swamped with excessive noise. The disadvantages are that the camera must be mounted on a tripod, and if anything in the scene moves between exposures it will not be rendered properly in the final image.

Alternatively, component images of different 'exposures' can be generated from a single Raw file. As we learned earlier, Raw images have greater exposure latitude than JPEGs as they are 12-bit. Digital photographs that are displayed on commonly available displays are only 8-bit. The advantage of generating the component images in this way is that a tripod does not have to used and moving subjects present no problem. Sadly, noise is more of a problem, especially at high ISO settings.

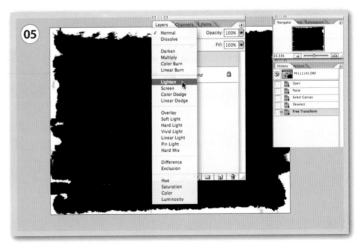

When it all comes together

By now it should be clear that all these Photoshop and digital-imaging skills aren't meant to be used solely in isolation – used together, they are hundreds of times more powerful. The cover of this book is a good example. It was shot using an Olympus E-300 digital SLR with a 7–14mm ultra wide-angle lens. Afterwards, the Raw file was processed, the colour cast was removed, the brightness and contrast were tweaked, unwanted details were painted out and finally the whole image was cropped, straightened, sharpened, saved and printed. Phew!

01 These details were removed with the Clone Stamp tool.

02 The vertical lines in the scene aren't quite vertical because the camera was pointing down slightly, and the wide-angle lens has exacerbated things. The perspective was straightened up using the Free Transform tool.

03 The mixture of daylight, fluorescent light and tungsten light has created a bizarre colour cast. This was corrected by clicking on a neutral part of the wall with the White Balance tool when the Raw file was processed.

04 Because the picture is so symmetrical, we can copy some of the roof from the other side of the frame to obscure this distraction. It has been copied as a new layer so as not to alter the original image irreversibly.

05 The camera's autoexposure system has underexposed the scene because of the predominance of white and cream in the frame. This has been compensated for with an exposure correction at the Raw processing stage.

06 The slightly blurred moving man gives the photograph a secondary focus point, after the impact of the magnificent lattice roof has been digested. However, he should be a bit further over, towards the bottom left third of the frame. The Clone tool was used to copy the figure from one part of the picture to another, while removing him from the original spot.

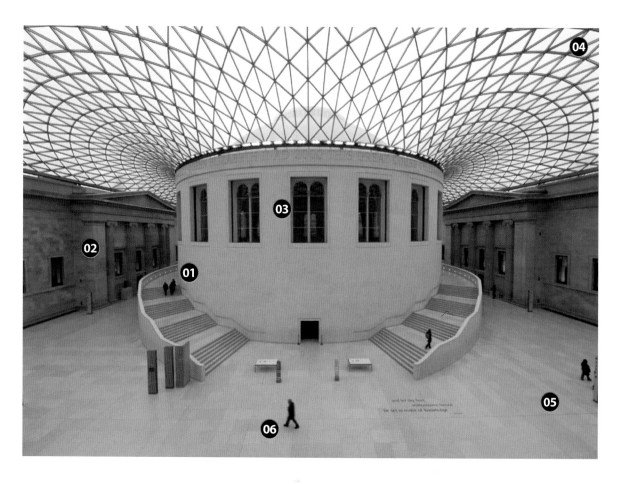

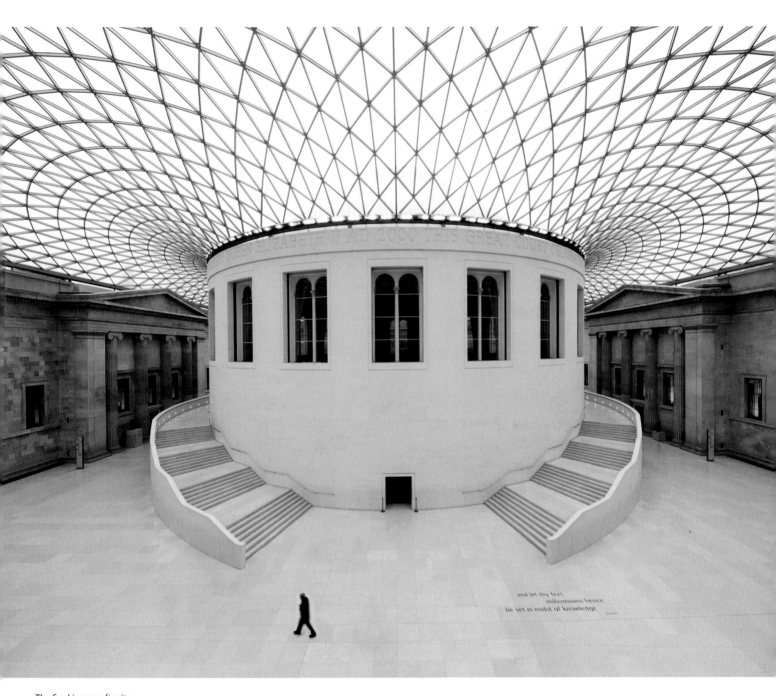

The final image after its
many adjustments.

Glossary

A

Artifacts Unwanted elements in an image that were not there when the scene was photographed. Artifacts can be caused by a digital camera when a picture is written to a memory card, or introduced during post processing in Photoshop.

Actions A method of automating a series of steps in Photoshop. Actions can be played back by clicking on buttons in the Actions pallet or through keyboard shortcuts. They can also be applied to a number of files in one go as Batch Process or Droplet.

Adobe RGB One of the most commonly used colour spaces used by digital photographers. Has a wide gamut of colours which correspond to those that can be printed by desktop inkjet printers.

Aspect ratio The ratio of a digital image's width to its height. The Aspect ratio of most digital SLR cameras is 3:2, which corresponds nicely to a 6 x 4 inch print.

B

Batch process A method of applying an Action to more than file at once.

Bit/Bit depth A bit is the most basic unit of data which a digital image is made from, and can be either 0 or 1. Bit depth refers to the number of bits of information used to describe the colour of each pixel in an image. Digital images are commonly 8-bit, meaning that each of the red, green and blue channels are described by 2^8 brightness values (= 256). Merging the red, green and blue channels together yields 16,777,216 colours (256 x 256 x 256).

Barrel distortion An effect caused typically by wide-angle lenses whereby straight lines that are parallel to the edge of frame appear to bend outwards. This is opposite of pincushion distortion. Barrel distortion can be corrected in Photoshop with the Lens Distortion filter.

Bleed A picture that is printed right up to the edge of the paper.

Burn tool Photoshop's Burn tool selectively darkens parts of a picture, in the same way burning in a traditional darkroom does. It's effect can be controlled with the Exposure slider.

C

Card reader Hardware deivce that plugs into your computer and allows you to read the contents of a media card without having to plug your camera directly into your computer.

Cloning Cloning is the process of copying pixels from one part of the picture to another in real-time, and is useful for removing unwanted details from photographs. In Photoshop this is carried out with the Clone Stamp tool.

Colorimeter A device for accurately measuring colour on a screen or print, and feeding this information back to a computer for colour calibration purposes. Colorimeters can create custom colour profiles to ensure accurate reproduction of colour throughout the digital workflow.

Colour depth Another term for Bit Depth.

Colour profile A description of how a device such as a camera or monitor, records or displays colour. Each device has its own colour profile, and several general profiles – such as sRGB and Adobe 1998 – are available too, and are good for editing images. Photoshop can help convert an image between profiles. The International Color Consortium (ICC) has laid down standards by which an image can be captured in cone profile and converted to another for consistent output.

Colour space The number and range of colours that a device such as a camera, scanner or printer is capable of capturing or outputting, as well as the method by which these colours are recorded and described.

Colour temperature The colour of supposedly white light from different sources. What we perceive as the same colour of light from an indoor domestic house lamp is a different colour temperature to that of the sun, or a camera's flash gun. Colour temperature is measured in Kelvin (K).

Compression The process by which the physical size of an image file is reduced when it is saved, so as not to take up so much room on disk.

CD-ROM/CD-R/CD-RW CDs can hold between 650-700MB of information, making them ideal for medium sized storage of digital photographs. A CD-ROM can only be read, whereas CD-R and CD-RW disks can also be recorded onto. The contents of CD-RW disks can be also be re-recorded and edited.

Continuous ink system A continuous ink system (CIS) lets large-capacity ink canisters be used in an inkjet printer, instead of the smaller standard-sized ink cartridges that are commonly supplied. A CIS usually consists of an individual bottle of ink with hoses connecting them to the printer's print heads.

Compact Flash A type of memory card. Compact Flash (CF) cards are more robust than other memory cards, and currently offer the highest capacity (up to 16GB).

Curves A method of adjusting an image's brightness, contrast and colour balance in a non-linear fashion.

Cropping The process of changing an image's size by removing parts of it. The Crop tool in Photoshop can be set to crop to specific sizes and aspect ratios.

D

Digital workflow The steps which a photographer works through while taking the image from a collection of ones and zeros on a memory card to a finished print on paper. No two workflows are the same and it is not uncommon for a photographer to have an individual way of working that is just right for them.

Dynamic range A measure of the range of brightness values that can be recorded in a photograph, from the brightest white to the blackest black. Digital cameras have a similar dynamic range to that of transparency film in traditional photography. Print film can capture a wider range of brightness values.

Dodging Photoshop's Dodge tool selectively brightens parts of a picture, in the same way that dodging in a traditional darkroom does. It's effect can be controlled with the Exposure slider.

DPI Dots per inch – a measurement of the number of dots output by an inkjet printer along one linear inch. Should not be confused with pixels per inch (PPI).

Duotone A technique for creating monochrome images using two colours. Duotone images may have a richer feel than straight-forward black & white pictures, or appealing colour casts that are similar to the sepia or selenium produced in traditional chemical darkrooms.

DVD-ROM/DVD±R/DVD±RW With a capacity of just over 4GB, DVDs (digital

Plug-in A small piece of software that adds extra functionality to an application like Photoshop. Plug-ins can be produced by third-party software developers to enable users to apply all manner of effects to their photographs.

Posterization A process by which the number of colours in a photograph is reduced, either intentionally for artistic effect, or erroneously as a by-product of adjusting an image's <u>levels</u>, for example.

PPI Pixels per inch – a common measurement of the <u>resolution</u> of an image while it is being edited on computer. Not to be confused with dots per inch (<u>DPI</u>), which is terminology used in printing.

R

Raw files Untouched data from the camera's sensor that hasn't had any processing to turn it into an image file. Must be converted with Raw processing software to produce a viewable image.

Resolution The detail recorded in a digital image, dictated chiefly by the number of <u>pixels</u> on a camera's sensor (as well as by the optical quality of the lens being used).

Red-eye reduction Software algorithms that attempt to eliminate the red eyes produced in a portrait illuminated with on-camera flash.

RGB A <u>colour space</u> whereby the colour of each <u>pixel</u> is determined by a red value, a green value and a blue value which are then mixed together.

ROC Restoration of Color. Technology developed and licensed by Kodak subsidiary Applied Science Fiction that attempts to restore colours in faded originals that are being scanned.

Rubber stamp tool Another term for the Clone Stamp Tool.

S

Scanner A device which turns a hardcopy photograph (print, transparency or negative) into an editable digital image.

SD card A type of memory card commonly used in digital cameras and mobile phones.

Sharpening A process for making the edges in an image cleaner. Sharpening does not actually improve image quality but make some images seem sharper to the human eye. All digital images need some sharpening at some point; it is often applied in-camera automatically.

SmartMedia A type of memory card commonly used in digital cameras and mobile phones.

Soft proofing The on-screen simulation of how an image will appear when it is printed.

sRGB An RGB colour space often used by digital cameras and editing applications. It offers a narrower range of colours that Adobe RGB 1998, but is better for images that are to be reproduced on screen, on a webpage for example.

T

TIFF Tagged Image File Format. A type of image file commonly used by photographers. TIFF files can record more detail than their JPEG cousins as they do not use lossy compression to reduce file size. As a consequence they are large in size, but can be compressed with the LZW lossless compression algorithm.

TWAIN Technology without an interesting name. Software that enables the control of a device, such as a scanner, from within a third party application, like Photoshop.

Transparency See Opacity.

U

Unsharp mask (USM) A commonly used filter used to increase edge-contrast in images and give them a sharper appearance.

USB Universal serial bus. A type of connector used to link computers, printers, scanners and digital cameras to each other. The latest iteration, USB 2.0, enables files to be transferred at a much faster rate than the old USB 1.1 standard.

Undo A command that reverses the last action performed on an image.

W

White balance A digital camera/editing software system that sets the <u>colour temperature</u> of a scene being photographed according to a number of presets (Sunny, Cloudy, Indoors, Flash, etc). Some cameras also allow white balance to be set according to a white sheet of paper photographed under the same conditions as a reference. White balance can also be set retrospectively in Photoshop if a <u>Raw</u> file has been captured.

X

xD card A small memory card used extensively in compact cameras made by Olympus and Fuji.

Acknowledgments

There are many people who have helped in the preparation of this book, and I'd like to thank them all. In particular, Neil Baber and Emily Pitcher of David & Charles have been unbelievably patient with me in the face of many missed deadlines, as has Nicola Hodgson, who had the onerous task of editing my rambling thoughts. Thanks also to everyone who posed for pictures: Amber, Chris, Fiona, Steve and Suzie. And a second (and massive) thank you to Suzie for all her support.

Index